UNSEEN LONDON

PHOTOGRAPHS BY **PETER DAZELEY**

UNSEEN LONDON

TEXT BY **MARK DALY**

F

FRANCES
LINCOLN

CONTENTS

INTRODUCTION	6
HIDDEN LEVERS	10
LAW AND ORDER	48
ARMY AND NAVY	102
THE FOURTH ESTATE	140
ROYAL LONDON	166
BODY AND SOUL	188
THE SQUARE MILE	234
PHOTOGRAPHER'S NOTE	268
INDEX	270
ACKNOWLEDGEMENTS	272

HALF TITLE *The door to No. 10 Downing Street.*
TITLE PAGE *The main staircase, Old War Office.*
LEFT *St Christopher's Chapel, Great Ormond St Hospital.*

INTRODUCTION

The fifty or so London buildings collected in the following pages are the eclectic vision of celebrated photographer Dazeley. At least forty of them are in use, doing the job they were always designed for. Most of them stand in plain sight, and some of them are open to the public – although not always the parts in the shown in the photographs. Included here are examples of industrial archaeology, historic sites, highly functional working technology, relics, structures ugly and beautiful, monumental and mean. They are coupled together under loose categories, but they can all, for various reasons, be described as unseen. Only two – Kidderpore Reservoir and the government bunker known as 'Paddock' – are completely hidden underground, showing no surface traces. Also hidden, derelict and below street level is the Roman bathhouse at Billingsgate, which is an ancient monument and the oldest structure in this collection. Other locations, such as Tower Bridge and the Thames Barrier, are unseen because it is far from obvious how their inner mechanisms work, and the concealed parts are as fascinating as the visible structure. Buildings in transition, whose metamorphosis is not complete, represent another category. At the time of writing, Television Centre, the former Naval and Military In and Out Club building and Battersea Power Station are examples of this. The sporting venues included are easy to access for paying visitors, but the unseen emphasis here is on the backstage technical areas. The New West End Synagogue and St Sophia's Greek Orthodox Cathedral have remarkable interiors that are hidden in the sense that their exteriors give little clue as to their magnificence. The respectful visitor should not find it too difficult to see some of the religious buildings included here, and in these cases it is a matter of being aware

The cooper's shop at the Ram Brewery in Wandsworth.

INTRODUCTION 7

8 UNSEEN LONDON

of days of worship and checking first. Buildings that have changed purpose, whose appearance does not match their current function, include County Hall, City of London School, the Old Royal Naval College at Greenwich and the Daily Express Building, all of them relatively recent conversions.

Another place in metamorphosis is the former Ram Brewery at Wandsworth, shown here. It was owned by Young's, who always claimed that it was the oldest British brewery in continuous operation, being able to trace its history back to the sixteenth century. The complex on Wandsworth High Street and alongside the River Wandle closed in 2006 and the Ram Quarter residential and commercial development is growing in and around some of the original buildings. Young's had always maintained traditional brewing practices, operating steam beam engines in the brewhouse, and maintaining a stable of dray horses for local deliveries until the end of operation. The stables are being refitted as a restaurant. The cooperage shown here was a marvellously evocative place, with rows of circular cast-iron columns supporting fish-bellied beams. In the Tun Room remain a spectacular pair of coppers manufactured by Pontifex & Wood, Shoe Lane, London, dated 1869 and 1885. These coppers and the engines are being preserved as part of a visitors' centre and brewing museum to be opened when the redevelopment is completed.

Some of the buildings in *Unseen London* are classic tourist destinations open to visitors, but the spaces and areas of buildings shown may not be open. It should always be a matter of checking first before visiting, and remember that photography may not be permitted. For some of the buildings described here, no public access is permitted and site security is strictly maintained. Open House London provides an opportunity to see many architectural secrets in a range of London's modern and historic buildings that are not routinely open. Its annual Open House Weekend takes place in September.

The old coppers at the Ram Brewery in Wandsworth, before redevelopment.

HIDDEN LEVERS

12　UNSEEN LONDON

BATTERSEA POWER STATION

The classic view of Battersea Power Station, seen across the Thames from Pimlico, has been secured and protected, although extensive new buildings have encircled it to the west and east. Many of the good angles on London's most massive landmark, once glimpsed from across all south London, began to disappear in 2016 as the new mini city at Nine Elms sprang up. As the scenery changed for ever, Battersea Power Station seemed to be emerging from a long twilight, its boiler house and turbine halls starting to be revived for a new life as an office, residential, restaurant and retail complex.

Battersea Power Station's closure came in 1983 – the technical electrical expression is 'thrown dead' – and it stood disused for years. The roof of the boiler house and the internal west wall were removed between 1987 and 1989 as part of a plan to develop an indoor theme park. That did not progress, and several changes of ownership and changes of plan followed. The site deteriorated with the shell remaining intact, generating controversy and a kind of poetic melancholy. A Malaysian consortium of Sime Darby, SP Setia and the EPF pension fund acquired the property in 2012. The photographs here were taken just before scaffolding was erected for the start of refurbishment.

Battersea Power Station may evoke a cathedral, but it is clearly steel-framed like a skyscraper, and deploys vast areas of concrete. It may claim to be the largest brick building in Europe, but its structural heart lies in I-section girders and thousands of steel reinforcing rods buried inside concrete pillars and columns.

PREVIOUS PAGES *Monumental switchgear, Control Room B side, Battersea Power Station.*

LEFT *Dials, Control Room A.*

The power station was built in two phases. Battersea A, with two chimneys, was completed between 1929 and 1935, and to imagine this it is necessary to picture the west half only of the current structure standing alone. Work began on Battersea B in 1937 and the four-poster layout was finally completed in 1955. There was a phase in the intervening years when Battersea was charmingly three-chimneyed, an appearance that was repeated during 2014 when the first of original chimneys was dismantled. During 2015 it stood with one chimney. A viewing platform and lift is planned for the north-western chimney.

The power station seems to be a gigantic monument to symmetry, although Historic England's survey shows this be false. The boiler house of the Battersea B is 16 ft (5 m) higher than the first, and the windows and doors differ in detail. Even the Blockley bricks are slightly different in size, colour and texture. There was an additional entrance, and more window area, in the eastern half of the station. The two-phase build programme is reflected in Battersea's greatest architectural secret: its beautifully appointed control rooms. These sit high in the station, in the upper part of the switchgear houses overlooking the turbine halls. The control room walls are trimmed with grey and black marble; the ceiling is glass and steel; the floor is teak. Banks of functional switchgear, voltmeters, ammeters and controllers are arranged in wall panels and in a semi-circular control desk. Everywhere the highest quality materials have been abundantly applied. Station B's auxiliary control room is more austere, reflecting its later construction, but equally impressive, with the main material being stainless steel. Some instruments are set in swivelling pedestals mounted on the floor and walls. Plans exist to convert Control Room A into a restaurant, preserving the switchgear and instrumentation as features.

Battersea has some strange truths, but also some myths attached. There is indeed a tunnel, or a pipe system, from the power station leading under the river, using surplus heat to provide a hot water

Stainless steel consoles and pedestals in Control Room B, built later in a cool utilitarian style.

HIDDEN LEVERS 15

16 UNSEEN LONDON

HIDDEN LEVERS 17

system and heating to the Churchill Gardens Estate in Pimlico. Control Room A is fitted with a parquet floor of the highest quality. But is it true that the operators were required to wear carpet slippers when they worked there? And who calculated that often-quoted fact that Battersea Power Station is the largest brick building in Europe, and exactly how many million bricks did it take? Accounts vary. Architect Sir Giles Gilbert Scott certainly did work on Battersea, but he was recruited late to the project and disliked the work being attributed to him solely, being more like a design consultant for the exterior. Scott himself would have certainly created a much more austere structure given a freer hand, and proved the point by drawing from scratch Bankside Power Station, now Tate Modern.

For many architectural Modernists of 1933, Battersea was insufficiently brutalist. The design of the chimneys came in for criticism at the time, with the rendered fluting being described as an aesthetic error, a concession to prettiness. The original turbine hall was once ceramic tiled and its stairs had Greek key patterns in the Art Deco way. Some remaining doors give a hint of the style. The vast boiler house contained nine Babcock & Wilcox boilers. The turbine halls on each side were once filled with the bass-baritone humming of five mighty Metropolitan-Vickers turbo-alternators. Most of the power station's coal arrived by river. Outside, near the river, stand two refurbished Stothert & Pitt cranes, which fed the long-vanished coal conveyers.

Amid the canyons of surrounding glass-fronted apartments, the full picture of the future Battersea Power Station has yet to emerge. Its spaces are becoming atria flanked by apartments and offices. Apple was announced as taking a major share of the office space in the boiler house as its London campus headquarters from 2021. A Tube station is opening to serve the power station, the new US embassy stands close by, with the Dutch embassy also coming to the area, in a regenerated South Bank.

OPPOSITE AND LEFT *Inside the outer walls of Battersea Power Station showing the dereliction, missing wall and no roof.*

OVERLEAF *Control Room A, with control desk, marble walls, elaborate ceilings and wooden floors of the highest quality.*

NEUTRAL EARTHING 66 K.V.

NEUTRAL EARTHING 66K.V. & 22K.V.

SUMMATION

INTERCONNECTOR 3-6

TOWER BRIDGE

The jagged profile of Tower Bridge is the very symbol of London and the least secret location in the city. Its neo-gothic façades of Cornish granite and Portland stone evoke a Scottish castle, but are built on a steel frame. Much of the original operating system for Tower Bridge still exists – some of it concealed, some on show, all of it solid, advanced Victorian engineering.

Tower Bridge was intended to improve road transportation to serve developments to the north and south, while allowing ships access to the many wharfs and warehouses that lined the River Thames as far as the arches of London Bridge – which for most vessels was the practical limit for upstream navigation.

A road crossing to the east of the City was needed to ease London's truly awful traffic problems, particularly on London Bridge. The new bridge had to be suitable for horse-drawn traffic and pedestrians, so could not be steeply graded. After years of debate and a competition, a design by architects Sir Horace Jones and engineer Sir John Wolfe Barry was selected. And after eight years in the building, Tower Bridge was completed in 1894.

What was needed was a way of instantly generating a smooth, linear action for raising the spans of the bridge. Steam was king in Victorian Britain, but steam did not provide the complete answer. It might have been feasible to lift the road decks directly, using engines to drive a train of gears through a clutch. That would have been slow and extremely

Bascule chamber under the south pier of the bridge. Below this chamber lie the steel caissons, which made the digging of the foundations possible, and above the operating machinery, including two accumulators.

HIDDEN LEVERS 21

OPPOSITE ABOVE *Lancashire boiler – one of four originals. The bridge depended on steam power until 1976.*

OPPOSITE BELOW *Steam age mechanical levers for opening the bridge, together with position indicators, and a panel for instruments displaying water and steam pressure.*

cumbersome. Steam engines were best able to produce reciprocating or circular motion, and such power could not be stored.

Electrical power held great promise in the 1880s, but at that time the crucial breakthrough needed to enable alternating current (AC) for municipal systems had not been achieved. The direct current (DC) system of the time was feeble and inefficient; the largest dynamo anywhere in 1888 produced just 500 horsepower.

The solution selected was state-of-the-art, being the application of hydraulic power, using water under pressure. This had been first developed by Sir William Armstrong for dockside cranes in the north-east of England. It was ideally suited to power cranes, lifts, presses and lock gates – and perfect for opening a bridge.

Disused elements of the original system remain in place, as a testimony to the ingenuity of the architect and engineer. Four classic Lancashire boilers housed on the south side of the bridge provided steam for relatively small two-cylinder tandem compound steam engines and pumps under the south approach road, generating water pressure of 750 pounds per square inch. Pipes took the high pressure water to six hydraulic ram systems called accumulators, two in each pier and two on the south side of the bridge. Heavy weights were lifted by water pumped into each accumulator shaft, and held at top of the travel with the inlet valves closed. With the weight held poised, power was stored, and it could be unleashed at the turn of a handle.

In each pier four lifting engines – water-powered three-cylinder motors – received water under pressure and turned gears to the bascules, opening the span. The bascules themselves carry heavy counterweights to the order of 400 tons, and raising them to 86 degrees could be completed in a minute.

The multiple engines, boilers and accumulators provided what modern engineers call 'high redundancy' – in that everything was duplicated and twice the required power was always available.

The pedestrian lifts to the elevated footways were also hydraulically powered, as was the crane mounted on the south side to unload coal from barges.

This system was entirely self-contained and dedicated solely to Tower Bridge, but, as a further back-up reserve, water could be drawn from the public power supply mains of the London Hydraulic Power Company, which had stations at Rotherhithe, Bankside and Wapping, providing a hidden system of liquid muscle across London for nearly 100 years. For many years it was common to see 10,000-ton merchant ships alongside just west of the Bridge. Hay's Wharf took over most of the facilities on the south side, where a forest of cranes worked.

On the north side, New Fresh Wharf accommodated particularly big vessels. All of this was dependent on the opening of Tower Bridge.

In 1965 the cranes upstream of Tower Bridge famously dipped their jibs to salute the passing of the funeral launch bearing Winston Churchill's coffin. These cranes were all finished with by 1969. The decline and death of London's working wharfs and docks, from its peak capacity in 1961, turned out to be swift. Tower Bridge opened fifty times a day during the first year of operation, but eventually road tunnels under the Thames, and the development of new enclosed docks downstream eased some of the traffic burden. The overhead walkways were out of use by 1910.

The quietly functional Tower Bridge was the furthest downstream crossing until the opening of the Queen Elizabeth II Bridge at Dartford in 1991. Tower Bridge still opens fifteen times each week on average, given twenty-four hours' notice, and the spans lift in the same way, with astonishing speed, smoothness, quietness and ceremony, now powered by electric motors driving an oil hydraulic system.

HIDDEN LEVERS 23

THAMES BARRIER

It is hard to find anyone with a bad thing to say about the Thames Barrier; its noble purpose is clearly understood. As surge tides and rising water levels became increasingly capable of swamping the capital, the Barrier was needed to protect against the threat and became operational in 1982. Londoners are aware of the catastrophic floods of the past.

Shining in plain view between Charlton and Woolwich, the Thames Barrier has its share of hidden features. Hardly anyone understands how it works because most of the time the main gates lie hidden under the river in the open position. A draughtsman-designer named Charles Draper, working for civil engineers Rendel Palmer & Tritton, is credited with inventing the rising sector gate for the Thames Barrier, said to be inspired by the internal workings of a humble domestic gas tap. The gate is shaped like a slice cut along the length of a solid cylinder – a sector. At each end of the sector are two full-diameter discs. The discs are fitted on spindles at the sides of the piers. Rotating these discs (properly called gate arms, seen on the sides of the piers) causes the gate to rise into the closed position between the piers.

Those who witness the Thames Barrier as it closes can see how the gate rolls up from below the water to block the river, but it is not possible to see how each open gate lies flat on the riverbed embraced in a giant recess. All the four biggest rising sector gates are recessed into concrete riverbed sills. Weighing 10,000 tons, they were cast in dry docks in 1979 and floated out and sunk into position.

There are ten spans, six of which are available to navigation.

The south side of Gate 9, with its signature stainless steel roof. Beneath lie the piles, sunk 79 ft (24 m) into the river bed to create the pier.

HIDDEN LEVERS 27

Between the five major piers are four 200 ft (21 m) spans, flanked by two outer smaller piers with spans of 105 ft (31.5 m). Four non-navigable spans, one at the south end and three to the north, complete the structure. The gates for these small spans work in the opposite sense to the main gates. They are visible when in the open position and are rolled into the river to close the span, and are called falling radials.

The muscular-looking yellow triangular frames on the downstream side of the piers are called rocking beams, and shift-and-latch mechanisms are on the other side. The rocking beams turn the gate arms to close and open the gates; the shift-and-latch mechanisms hold the gate in the selected position.

The design for any flood barrier risks looking like a brutal monumental sluice, but the Thames Barrier, one of forty-one designs put forward, turned out to be a masterpiece in scale and proportion, and oddly beautiful. During construction, the naked concrete bullnose piers did not look promising, but on completion the Barrier turned into a graceful swan. Many have remarked that the curious shining hoods on the piers which house the machinery evoke a science fiction structure, or a surreal bishop's mitre. This stainless steel roof cladding is mounted on wooden frames. The double-curvature roof shapes are aerodynamically functional, offering minimal wind resistance without increasing the concentration of gusts around the piers. One report has claimed that these narrow strips of cladding metal, which are joined by folding the end of one section over the next, had to be fitted by right-handed tradesmen on one side, and by left-handers working on the other.

The metal cladding is maintenance free, and has never needed cleaning, but as the Thames Barrier celebrated its 25th anniversary in 2009,

The window of the main control building on the south side. The Barrier Controller makes the decision to close the Barrier based on weather forecasts, tides and surge predictions. The gates are closed in pairs, the outer ones first, and although the major gates can be closed in 15 minutes, a complete closure is timed to take 1½ hours to prevent generation of a reflective wave.

some of its systems have been upgraded or replaced, including hydraulic valves, all the cranes on the piers, the latching mechanisms, and the electrical cabling. All upgrade and repair work is carefully phased – nothing that causes the Barrier to be inoperable for more than six hours is permitted; if longer is required, the gate is closed. The Barrier was designed to give protection until 2030, but the Environment Agency estimate it can safely provide protection until 2070, given the current rate of rising water. Downriver, the banks of the Thames were historically littered with epically unpleasant things, including a gigantic gasworks, sewer outlets, munitions factories, explosives magazines, firing ranges, petrochemical works, asylums, hospitals for infectious diseases, plague graveyards and prison hulks. The decay of the disused dock systems hung over the Thames for twenty-five years. After the Barrier came, the Thames became cleaner, as sewage disposal was improved, unpleasant remaining riverside processes closed and the dock areas were rehabilitated. Children visit, and are encouraged to sketch ducks and fishes. The Thames Barrier has come to represent more positive years for the river.

One of two full-length tunnels running from the control room carrying power cables and drains. Fire protection and prevention in the tunnels is comprehensive.

WHITE FIGURES
REFER TO
ORDNANCE DATUM
RED FIGURES GIVE
DEPTH ON INVERT
(−20·00 O.D.)

CROSSNESS AND ABBEY MILLS PUMPING STATIONS

Crossness Pumping Station engine house is a splendid Romanesque industrial building which stands south of the Thames about 12 miles (19 km) east of Trafalgar Square. Its counterpart across the river in the East End is Abbey Mills, exotic in appearance. They are two conspicuous features of what remains one of London's hidden engineering secrets – its mid-Victorian sewer system.

The engine house at Crossness is a tribute to extensive restoration and preservation. The interior houses a remarkable octagonal pavilion with arched screens. Wrought iron and cast iron are used extensively for the capitals, columns, floors and spiral staircases, and there is much brasswork for details such as the handrails. Despite the use of so much metal, the decorations are delicate iron evocations of leaves, vines and flowers, in places intertwined with the Metropolitan Board of Works' monogram. Bright colours are used, as originally applied in 1865. Above lies the beam floor, and in the corners are four massive engines, each with a 52-ton flywheel.

At Abbey Mills, the main engine house, opened in 1868, is still in use. Its steam engines were replaced with electrical systems during the 1930s, and the electric motors and pumps remaining in the building now serve as a reserve system for Thames Water. Abbey Mills' ironwork was designed by the same architect as at Crossness, Charles Driver. The columns and arches are now painted in more muted colours. The building is often described as 'Byzantine' or 'gothic', but its style is hard to pin down precisely. The high dome and lantern are Russian in appearance and there were once two massive Moorish chimneys. Electrical control panels and instrumentation from a later age, now dated, do not look out of place in the Victorian engine house.

Behind the creation of both these buildings lay the desperate need to clean up the River Thames. In the early nineteenth century, the fact that contaminated water was the true cause of cholera, which was to kill more than 30,000 Londoners between 1830 and 1855, was imperfectly understood. It was not until the Great Stink of 1858, when the polluted Thames generated a stench so powerful that the Houses of Parliament were rendered barely habitable, that politicians took action.

The solution, designed by chief engineer to the Metropolitan Board of Works Sir Joseph Bazalgette, was typically Victorian in its ambition. A network of main sewer tunnels running parallel to the Thames would be built, collecting both waste water and surface water, and carrying it to outfalls far downriver. As the districts of London lie on different levels, the challenge was to lift much of the waste water to a level high enough to allow it to flow into the river. Three main intercepting sewers on the north side of the river at low, middle and high levels, and three on the south, would feed waste water into outfalls at Barking and at Crossness. Abbey Mills Pumping station was needed to raise the water from the lowest interceptor sewers to reservoirs, from where it could flow into the river.

On the south side, Crossness was able to discharge sewage directly into the river at high tide, but during low tide powerful pumping engines were needed to raise sewage water into a roofed reservoir (about the area of five football pitches) to await the change in the river level.

Sewage level indicator, Abbey Mills Pumping Station.

Pump room, Abbey Mills Pumping Station.

The Southern Outfall Sewer Pumping Station at Crossness lay on the edge of what was in 1865 a bleak marsh at Erith. To the west lay Woolwich Royal Arsenal, whose firing ranges, magazines and test areas were starting to sprawl over hundreds of acres of marsh, mostly closed, dangerous and secret – a place redacted from maps.

Abbey Mills stands close to Bromley-by-Bow and was further from the outlet. On completion in 1868 it was on the outer edge of London, with open country beyond. Within a year it was joined to the east by the gigantic Beckton Gas Works, a Hades-like collection of retorts, chimneys, gasometers and tar beds. Sewage from Abbey Mills flowed into the Northern Outfall Sewer, which curved closely around the gas works and discharged directly into the river at Barking. Here the concentration of unpleasantness was exceptional, and the outfalls at Barking and Crossness were frequently overpowering. This did briefly represent a kind of progress, because sewage was being shifted out of London to the downriver outlands, but soon the grim state of the banks raised another stink. A second phase of improvements was required as the realization grew that raw sewage could not be pumped into the Thames in the expectation that the tides would take it away.

From 1887 precipitation bed systems at Barking and Crossness came into operation to extract sludge from waste water. Sludge was loaded onto a fleet of purpose-built vessels, which steamed downriver to discharge it in the deepest parts of the estuary, a system which operated for more than a hundred years. The fleet of sludge carriers, numbering sixteen over

ABOVE *Albert Edward fly wheel, Crossness Pumping Station.* OVERLEAF *Main pump room, Crossness Pumping Station.*

time, performed that duty until EC rules outlawed dumping in 1998. Now all sewage is processed and some of it is incinerated at Crossness and Beckton.

As the sprawl of London caught up with Crossness, Woolwich Arsenal closed, and from 1967 Thamesmead town was developed. The original four giant simple engines had been updated to triple expansion compounds years before, but the last of them had been decommissioned by 1956. Too big to dismantle easily, the engines – named Prince Consort, Victoria, Albert Edward and Alexandra – together with the building housing them, remained intact but fell into dereliction. As years passed, it was discovered that the engines at Crossness are the largest remaining rotative beam engines in existence anywhere. After years of negotiation, and the establishment of a volunteer trust, work started on the restoration of the building and one engine in 1985. Prince Consort was the subject of a painstaking rebuild to working order by the Crossness Engines Trust, and was returned to steam in 2003. Work is proceeding on Victoria. Crossness is open to visitors four times each year for steaming demonstrations.

WILLIA
G ON

BT TOWER

BT Tower has always been changing. When it was commissioned, it was GPO Tower, popularly it was known as the Post Office Tower, later becoming British Telecom Tower. Its appearance has also changed significantly over time. A building once praised for its functional shape has lost connection with its original main purpose, a fact that seldom registers with the millions of Londoners who glimpse it daily.

In 2011, all the communications aerials massed on the BT Tower's open galleries were quietly removed. It was a symbolic moment, as the last operational dish had stopped functioning five years before. BT Tower remains packed with electronic switching systems, and is a key part of the UK broadcast and communications network. Many UK and international broadcasters, production companies, and service suppliers have links to the tower but these now rely on optical fibre cabling, not microwave radio aerials.

At the dawn of the 1960s a massive increase in demand for telecommunications and broadcast services was developing, and microwave technology was the best way to handle it. Museum Telephone Exchange nearby was already established as a communication focal point. The building had a mast on the roof, and sat on top of an existing Post Office cable tunnel. It had long been connected by cable to BBC Broadcasting House, and a pioneering microwave link feeding programmes to Birmingham had been functioning since 1948. With more channels and high-quality colour television coming, at the same time as a huge increase in demand for telephone connections, the decision was taken to combine capabilities.

After initial design work started on the proposed structure, then to be called Museum Radio Tower, it was decided to include a restaurant and observation deck. A trend had been set in Europe when Stuttgart included a public observation level in its new radio transmission structure, completed in 1956.

Dortmund went one better in 1959 by including a revolving restaurant in its broadcast tower. Landmark restaurants followed in North America with the Seattle Needle, a building that had no communication function, but high status. To some extent all were virility symbols in technological and architectural terms, boosting image and prestige. Yet none of them combined the versatile qualities of the London tower. On completion in 1965, the Post Office Tower and the four-storey building incorporated below (into which Museum Exchange had been absorbed) were able to handle 150,000 simultaneous telephone connections and to provide forty channels for television.

The observation floor proved highly popular, making it London's leading tourist attraction. The Top of the Tower

BT Tower is stabilized by a giant collar at fourth floor level.

38 UNSEEN LONDON

LEFT AND ABOVE *A reminder that BT Tower was developed from the site of telephone exchange. Much conventional telephone exchange racking occupies the lower levels.*

restaurant may have put novelty ahead of style – it issued a Certificate of Orbit to diners – but was successful. Public access turned out to be short-lived, as a terrorist bomb in 1971 caused the observation deck to close, and it has never re-opened. The restaurant operated until 1980.

Gradually, the tower slipped down the rankings of high buildings in London. In 2017 it was number 11 and it will certainly descend further. The public areas of the building are unlikely to re-open, but the tower has the legacy of being a public building. The restaurant floor still sometimes rotates for corporate guests.

BT Tower is built around a tapering cylinder of reinforced concrete, with the walls varying in thickness from 2 ft (60 cm) at the bottom to 1 ft (30 cm) at the top. It is described as curtain-walled, as the stainless steel window frames and multi-glazed glass enclosing the tower do not bear any structural load. The curtain wall is discontinued between floors 17 and 18, leaving open galleries for the aerials and plenty of room for growth in capacity. 'Shoot-lines', aiming in all directions to other towers

ABOVE *This 2-horsepower electric motor, still operational, turns more than 30 tons of restaurant floor through a single small gear. A rotation takes twenty-five minutes.*
RIGHT *Old exchange floor 14.*

and masts, ideally required a circular structure and the need to maintain precise and steady alignment of the narrow microwave beams meant that less than one foot of sideways movement could be permitted in the tower. Gripped by a 80-ft (24-m) collar at fourth-floor level, separately connected to the ground floor structure and secured at its base on a concrete pyramid, it is exceptionally stable.

When the tower was completed, eight huge horn-shaped antennae dominated the structure, as early films and photographs show. Later came many more advanced parabolic dishes. In the new century some of the twenty-nine aerials remaining on the tower were in a dangerous state, suffering corrosion and shedding bolts and brackets. Serious consideration was given by planners to replacing them with non-functioning fibreglass replicas, but it was decided the listed status of the building did not cover the aerials, and they were removed.

HIDDEN LEVERS 41

42 UNSEEN LONDON

ALDWYCH UNDERGROUND STATION

On one side of the station building the nameplate reads Aldwych and on the other side it says Strand, both denoting the same disused Underground station on a branch line going nowhere. Built on a route which once aimed at reaching Waterloo, Aldwych remained operational until as late as September 1994. As the most recent central London Tube station to be completely closed without replacement, Aldwych has not so far generated a great mythology, yet it is unique among the seventeen lost London Underground stations. It remains intact, with platforms and running rails in place and conductor rail electrified. Trains sometimes still run into and out of the station. Police officers, fire fighters and other unidentified gentlemen in civilian clothes frequently gather by the entrance in Surrey Street before moving discretely inside. Sometimes big trucks park close by, and heavy technical equipment is carried in. Aldwych station is closed, but clearly not dead.

Aldwych Tube occupies a peculiar position in every aspect, being a branch line terminus on a system that operationally favours through running from end to end, and sited fractionally off-centre for good business. It opened in 1907 on the southeastern corner of London's Theatreland, at the time of a theatre-building boom. Across the road was the Gaiety Theatre, home of productions starring exotic Edwardian dancers, on the end of the newly built Aldwych crescent. When the station opened, the area was undergoing a massive improvement programme.

Aldwych was always a dead-end, and part has been disused since 1917. Still intact, the lines on eastern Platform 2 run to a stop block, and the old Strand station name can still be detected on the wall, which has been used by London Transport for mock-ups of prospective designs. It is also used for terror attack drills and is the most popular Underground station for filming.

One of the two surviving Otis electric lifts, non-operational, with access to the platforms now being by spiral staircase. At certain times tickets were issued from a booth in this lift.

This was designed to relieve the hopeless congestion of horse-drawn, Victorian London, especially between St Mary-le-Strand and St Clement Danes churches. Widened roads, a tramway underpass at Kingsway and the station at Aldwych completed the modernization. The theatre boom lasted until the summer of 1914, the splendid high-water mark of Edwardian England.

Despite its position close to the heart of London, Aldwych station struggled to be viable from the start. While the West End teemed with office workers, tourists and theatre goers, the positioning of the station, then named Strand, was not ideal, and so long as it remained a spur it was always going to be tricky to operate trains back and forth to Holborn.

It was built at the end of an age when mass transit systems were still seen as potentially profitable businesses rather than merely a public service. American investment poured into many enterprises in Edwardian England, and the central sections of today's Bakerloo, Piccadilly and Northern lines remain as its legacy. Charles Tyson Yerkes, a buccaneering financier who had helped develop Chicago's streetcar system and was responsible for funding the Loop elevated railroad there, invested in a scheme to build an underground railway from Hammersmith to Finsbury Park.

This was the Great Northern, Piccadilly and Brompton Railway, and included in the plan was the possibility of an extension southwards from Holborn to Temple or under the Thames to Waterloo, but firstly to Aldwych. The company's corporate identity can be seen outside in the ruby-red glazed

Cream interior decoration with green tiles was the house style of the Great Northern, Piccadilly and Brompton Railway.

terracotta station exteriors, designed by architect Leslie Green, and in the Arts & Crafts tiling and detailing on the interiors. It is one of thirty stations designed by Green, most of which can be still seen, from Holloway Road to Gloucester Road, from Tufnell Park to Elephant & Castle. The railway was soon amalgamated into the London Electric Railway, and came out of private ownership in 1933 with the formation of the London Passenger Transport Board. It was slated for closure in 1939, and did close during the war, when the station served as an air raid shelter, and one of its tunnels was used for housing national art treasures, including the 100 tons of the Elgin Marbles. Reprieved and re-opened in 1946, a bid was made to extend the line to Waterloo in 1948 and again in 1965. But the station remained a lame duck in the transport system, and as few as 450 people a day were using the station during its last year of operation.

Today Aldwych station remains intact, with its two short platforms and two separate tunnels to Holborn, the eastern tunnel and platform having been disused since 1917. The booking office has been restored, and corporate events and theatrical productions have been staged in the station.

As for the equipment regularly seen shipped into Aldwych, it is one of London's most well used locations for television and feature films, which include *Atonement*, *The Krays* and *V for Vendetta*. The emergency services and other organizations regularly use the station for important training exercises. Trains are run in and out of the station for their benefit of emergency workers or filmmakers.

KIDDERPORE RESERVOIR

A truly hidden London structure, the graceful Victorian brick arches of Kidderpore Service Reservoir in Hampstead lay concealed for fifty years. For a few months between 2013 and 2014, it was briefly possible to see a Victorian architectural gem.

The reservoir was built in 1867, and in recent years has acted as a holding tank for the London supply network, keeping treated water available at times of high demand. It is effectively an underground basin reservoir and has always been roofed. The last covering was a lightweight aluminium barrel roof system fitted in 1963, but land movement had caused some damage and the roof needed replacement. The reservoir was decommissioned, drained of 12 million litres (2.6 million gallons) of water, and the roof dismantled in 2013. The exposed structure was scrutinized. Nine parallel rows of finely constructed brick arches (which had supported the roof) stretched from end to end, on a brick floor and with brick end walls. The arches were found to be in perfect order. Except for some localized improvements to the walls, the structure needed no repair. Engineers relished the opportunity to examine the empty basin and exposed arches.

Lofty Hampstead – parts of which sit more than 400 ft (120 m) above sea level – had always enjoyed rather better quality water than those parts of London that depended on supplies from the Thames. The River Fleet rises in two places on Hampstead Heath and then descends, flowing below London to join the Thames at Blackfriars. Early attempts to regulate the water supply survive in the form of Hampstead Ponds. By the mid-nineteenth century, some more positive action was required to improve water supply. Sewers were enhanced and in 1866 the West Middlesex Water Company obtained powers to serve parts of Hampstead, constructing Kidderpore Service Reservoir and a waterworks alongside it. The reservoir took its name from nearby Kidderpore Hall, named after a neighbourhood of Calcutta. The hall had been built by a wealthy trader who returned from India with a fortune.

The reservoir is in Platts Lane, off the Finchley Road. Many local residents did not know it existed until construction work began on the replacement roof. Operated by Thames Water, it supplies drinking water to 11,000 homes in north London, and is one of perhaps a dozen brick reservoirs in London.

The survival in good condition of Kidderpore's brickwork after nearly 150 years was astonishing to many of the locals, who visited the drained reservoir and marvelled at the archways' resistance to erosion. It was less of a surprise to water industry engineers, who say that the longevity of certain types of brickwork in submerged conditions is well understood and long-established. It seems that Victorian engineers building Kidderpore Service Reservoir exploited the latest developments in building materials to make a long-lasting structure, rather than just depending on robust heavyweight construction. These included the use of modern Portland cement for making mortar, and particular types of hard engineering bricks. The famous London sewer system, completed by Sir Joseph Bazalgette just before Kidderpore was first commissioned, depends on more than three million of these bricks, which lasted well in the toughest environment, constantly scoured by rising and falling corrosive waste water.

With the completion of its new concrete roof in 2015, Kidderpore reverted to being Hampstead's own modest Atlantis.

Kidderpore Reservoir, drained, with its roof removed for restoration.

LAW AND ORDER

COUNTY HALL

Today, County Hall is mostly a luxury hotel, and partly a separate budget hotel. It also contains an aquarium, a restaurant, private apartments, a gruesome theme attraction and the ticket office for the London Eye. It has also been an art gallery and a film museum. County Hall has housed diverse enterprises over the last thirty years, as this huge building has been adapted to new purposes after the Greater London Council was abolished in 1986. Although its original municipal government role is a fading memory, County Hall's best and most hidden feature is the Council Chamber, which remains perfectly preserved in its centre.

The octagonal chamber could seat 200 members in a tiered horseshoe arrangement of seating. Green veined marble from Greece and black Belgian marble are used on the walls of the chamber and Italian marble on the columns. The chairman's seat is reputedly made of black oak from a tree hewn at Villiers Street across the river. Bronze and leather are lavishly disposed about the chamber, carved lion-head decorations abound on the woodwork and the carpeting is bright blue. Four tall windows allow natural illumination.

Equally imposing is the ceremonial staircase, with its columns and barrel-vaulted ceiling. At the top of the staircase is a marble-lined lobby, which surrounds the Council Chamber.

Some original corridors of County Hall remain, bearing a more utilitarian style of decoration. They are survivors of what was once estimated to be over 5 miles (8 km) of parquet-floored passages, running lengthways and crossways with a complex room-numbering system. The building's interior was reworked several times to increase accommodation over the years, but it is possible in places to imagine the main layout, with white

PREVIOUS PAGES *The debating chamber, County Hall.*
RIGHT *The Council Chamber.*

LAW AND ORDER 51

LEFT *Record of the Leaders of the London County Council and Greater London Council.* RIGHT *The entrance staircase.*

glazed-tile internal courtyards and lightwells, two splendid main doorways for council members and officers, and several minor entrances for staff. Chimneypieces and fireplaces abounded in the offices and rooms. Rooms may at one time have totalled 900 in various styles, reflecting the hierarchy of the place, varying between lavish and austere, some oak-panelled, some deal-panelled, with plaster walls in the basement. The rooms along the river frontage were particularly elegantly appointed, with fireplace and bookcases. The exterior stone carving and statuary, most of it on the river side, remains intact. Some areas, including the Council Chamber, are available to hire for corporate purposes. Predictably, it has featured in several feature films masquerading as exotic locations.

The name County Hall is now understood to describe the original long continuous Portland stone building designed by Ralph Knott around a central crescent facing the river, built between 1907 and 1922 to house 2,300 personnel. But County Hall has been greater than that. Additional responsibilities were taken on by the London Council in the last century, which ranged in early days from tramway supervision, licensing of premises and then later included social care, vehicle licensing, town planning, administration of council housing and education. County Hall and its staff just kept growing. Two new eight-storey office blocks were built alongside the original building, starting in 1936, and two more annexe buildings were added after 1960, the last being finished only in 1974, when the final extensions and infilling of the main building were completed. Taken together, County Hall was by then a colossus, accommodating

Riverside suite of offices.

up to 8,500 staff. In political terms it had become a sacred monster with a target painted large on its back. Construction had started in Edwardian days and continued during the era of growing social responsibility, through two World Wars and beyond. The London County Council had become the Greater London Council, but economic and political changes made it vulnerable to mandated decentralization and devolved responsibilities.

After the GLC was dissolved in 1986, there was a ten-year tangle of planning issues covering the future use of the buildings. At the time, County Hall represented an unwieldy proposition for any owner, and there was a genuine concern no viable future use could be found. The Inner London Education Authority was housed there briefly, and there were proposals for County Hall to be converted into a police headquarters, or even a prison, but the political climate favoured sale into private ownership over public use, and the building was sold to a property developer. Its future was cemented in 1998 with opening of the London Marriott Hotel County Hall, which was built with an opening on the Westminster Bridge Road side which had once been the carriage entrance. The London Eye opened by the river a year later, a Premier Inn budget hotel was established at the northern end, and the London Aquarium and the London Dungeon moved in. Other enterprises have come and gone. Most of the 1930s County Hall buildings have been converted into private apartments and extended. The two post-war annexes were demolished and hotels built on those sites, making the area a distinct hotel cluster.

FOREIGN AND COMMONWEALTH OFFICE

From 1806, Britain's first Secretary of State for Foreign Affairs, the rakish Charles James Fox, along with twenty of his successors, used a Westminster office situated in a ramshackle house in Downing Street. In 1852 one of its ceilings collapsed a fraction too close to the incumbent, Lord Malmesbury.

The incident came at a time of a growing British influence on the world stage, with the mid-Victorian period representing the peak of power. For a replacement building, a purpose-built bureau, rivalling the Quai d'Orsay in Paris or St Petersburg's General Staff Building, was planned. George Gilbert Scott, the project's architect, preferred the gothic style, but Lord Palmerston, the Prime Minister, favoured Palladian. The Italianate style prevailed. Construction on what would eventually be known as the British Foreign and Commonwealth Office commenced in 1861, with completion in 1868. Matthew Digby Wyatt, Scott's architectural partner, designed the India Office Council Chamber and the Durbar Court. English sculptors Henry Hugh Armstead and John Birnie Philip created relief portraits for the building's external stone façade, with subjects including Alfred the Great, Drake, Cook and Wilberforce, along with a phalanx of allegorical statues representing Law, Art, Commerce and the like. The building housed four different government departments: the Foreign Office and India Office initially, with the Colonial and Home Offices moving in by 1875. Standing on King Charles Street, its dignified exterior hardly rates a second glance by the thousands of tourists who pass through Whitehall, and the building is not highly ranked by enthusiasts of architecture. The interior is a different matter.

The India Office Council Chamber's importance in nineteenth-century foreign relations is emphasised by its height and size, and its elaborate use of gilt in a room used regularly by the Secretary of State for India and his council from 1868 to 1947. Dominating the room is the 1730 marble chimneypiece, the work of Flemish sculptor Jan Michael Rysbrack. Britannia is seen receiving gifts from the East, with Africa represented by a figure leading a lion, and Asia symbolized by a figure leading a camel. On either side of the fireplace, portraits of Robert Clive and Warren Hastings are testimony to erstwhile colonial glory, while furniture includes nineteenth-century mahogany chairs, and a newspaper stand brought from East India House. With the 1947 demise of the India Office its building was taken over by the Foreign Office, with the chamber hosting the 1948 London 6-Power Conference for discussions on Germany's future role by democratic and federal governance in the US, British and French sectors. Later, preliminary talks for early meetings of NATO officials were held in the chamber that in the twenty-first century is still used for daily meetings and conferences on international affairs.

At the nucleus of the Foreign and Commonwealth Office is the Durbar Court (a Persian word meaning Shah's Noble Court), based on designs for the courtyard of Rome's Renaissance Palazzo della Cancelleria. The London cortile's mosaic of tiles was influenced by Italian and Indian artistry, and the ascending levels of columns on all four sides are supported by ground floor Doric and first floor Ionic columns of polished, red Peterhead granite, and top floor Corinthian columns of grey Aberdeen granite. The courtyard's pavement is Greek, Sicilian and Belgian marble. An open courtyard had been envisaged, but the addition of the glazed cast-iron roof, inspired by Wyatt's work at Crystal Palace for the Great Exhibition and

The Grand Staircase, Foreign and Commonwealth Office.

Paddington station, allows flecked reflections of sunlight to seep into exotic surroundings. First used in 1867 for a reception honouring Ottoman Sultan Abdülaziz, the name Durbar Court only dates from 1902, when some of Edward VII's coronation celebrations were held there.

When designing what became known as the Locarno Suite, Scott envisioned an aura of grandeur by using space to create a 'Drawing-Room for the Nation' to host great occasions. The suite comprised three rooms – the 'Cabinet Room' (now known as the Grand Reception Room), the Conference Room and the smaller Square Dining Room – and guests entered via the left side of the grand staircase. The Dining Room, called the Cabinet or the Small Dining Room, was invariably used by the 3rd Marquess of Salisbury as his office, and his portrait hangs there. In 1925, the suite witnessed the signing of the Locarno Treaties to improve European diplomatic relations and, following some redecoration that same year, became known as the Locarno Suite. In 1935, the suite was chosen for the opening session of the International Naval Conference, and also hosted a dinner party for the state visit of President Lebrun of France in 1939. During redecoration in the 1990s, removal of plasterboard and grubby red silk hangings disclosed fading olive and gold decor with red and gold borders, enabling restorers to match the original colours to return the room to its former magnificence.

OPPOSITE *The Locarno Suite.*
ABOVE *Sigismund Goetze's painting* Britannia Pacificatrix, *showing Britannia victorious after the First World War.*
OVERLEAF *The Durbar Court.*

BIG BEN

Big Ben is probably the most photographed building in London. Almost all the tourists who come to the capital have the great clock tower of the Palace of Westminster firmly on their itinerary. This is partly because it is unique – there is really no other building in the world quite like it – but also because its huge clock and sonorous bells seem to embody the best of British engineering and accomplishment. Yet the story of the building suggests something different, and the familiar exterior conceals a complex and intriguing interior.

Big Ben is, strictly, not a building at all. The name refers not to the tower, but to the giant bell on which the clock strikes each hour, though the name long ago passed into common usage as a description of the whole structure – tower, clock and bells. It is thought to have acquired its sobriquet in reference to either Sir Benjamin Hall, the Chief Commissioner of Works in the 1850s, or Ben Caunt, a giant boxer of the period.

The tower of Big Ben stands 316 ft (96 m) high, and the staircase that winds up to the belfry has 334 steps, with a further fifty-nine to the lantern at the summit. The building, now officially known as the Elizabeth Tower, was begun in 1843, to designs by Sir Charles Barry, following a disastrous fire nine years earlier. Unusually for the period, the central core of the tower was erected first and the exterior added as the structure rose, but progress was slow and, when completed in 1859, the project was five years behind schedule. The centrepiece of the tower was to be a clock of unprecedented size and accuracy, and a competition was held for its design in 1846. The requirement was that the first strike of each hour should be accurate to within one second, and after five fruitless years a design was accepted from Edmund Beckett Denison, an MP with a strong amateur interest in horology, who was to become Lord Grimthorpe. The clock was constructed by E.J. Dent, a London firm more accustomed to manufacturing high-class pocket watches and chronometers for the Royal Navy. Grimthorpe's enormous clock has a pendulum 14 ft 5 in (4.4 m) in length and a mechanism 15½ ft (4.7 m) long, weighing around 5 tonnes. The clock was completed in 1854, but stood in Dent's workshops pending completion of the tower and was not installed until 1859.

The clock controls five bells, four to strike the quarter hours and mighty Big Ben itself. The current bell is the second, a replacement for the original which, to continue the theme of this troubled enterprise, cracked during testing in 1858. The 16-ton monster was broken up and recast to a lighter, but slightly

The top of the clock tower, housing the Ayrton Light, which is lit whenever Parliament meets after dark. The lantern is named after Thomas Ayrton, the first Commissioner of Works, who had the lamp installed.

larger, specification. The new bell survived initial testing but proved too wide to be hauled directly up the tower. It was turned through 90 degrees and, over thirty torturous hours, winched into the belfry. Next, the hands on the four enormous dials proved too heavy and stopped the clock. The solution lay in hollow minute hands – which are 14 ft (4.2 m) long – made from copper. The clock was started in July 1859, but the drama continued two months later when Big Ben developed a crack, and was silent for four years. The crack was said to have been caused by the deployment of a hammer that was too heavy for the bell. It was repaired, but the crack is visible to this day, and audible in the bell's sonorous, slightly imperfect tone. The mechanism has belied its troubled gestation by performing with remarkable accuracy. It has undergone few modifications since 1859 and is still regulated by the use of old pre-decimal coinage, which is placed on the pendulum rod. The addition of a single old copper penny causes the clock to gain two-fifths of a second in twenty-four hours.

RIGHT *The winding mechanism that powers the clock, which uses old pennies as weights to regulate the time.*

OPPOSITE *The 334 limestone steps to the belfry in the Elizabeth Tower.*

LAW AND ORDER 63

ABOVE *Inside the south clock face.*

OPPOSITE *The bell Big Ben, showing its crack and hole.*

WHITECHAPEL BELL FOUNDRY

The place where the mighty bell of Big Ben was cast and repaired, the Whitechapel Bell Foundry, finally closed its doors in May 2017. The foundry was based in the building it occupied since 1670 after the Great Fire of London, and the company history dates back at least 100 years before that, having claim to being the oldest manufacturing company in Britain.

Behind its eighteenth-century frontage lies a cave of manufacturing secrets. Here craftsmen used goat's hair and manure for moulds, and performed esoteric tasks with metal, wood, sand, graphite and clay. In the tuning shop, the bellfounder used a vertical lathe to shave fine bands of metal from the inside to achieve the final pitch. In other workshops frames and wheels for swinging bells were produced and handbells were an important line.

The outline template gauge for Big Ben framed the entrance door. England's heaviest change-ringing bell, the Liverpool Cathedral tenor, weighing over 4 tons, was produced here, and the world's first peal of sixteen change ringing bells was installed by Whitechapel at the Church of St Martin in the Bull Ring, Birmingham, England. The Liberty Bell, supplied to Philadelphia in 1752, was made here, as were the famous Bow Bells of St Mary-le-Bow at Cheapside. The eight royal jubilees bells cast for the City church of St James Garlickhythe in 2012, were first mounted on a barge to lead Queen's Diamond Jubilee Pageant on the Thames.

The steadiest period of work in the foundry's history came as bombs started to fall on the East End. A series of contracts awarded by the Admiralty to cast alloy components for submarines kept the foundry busy through during the Second World War, while during the 1950s a spate of repair and replacement work on war-damaged bells occupied the Foundry. The company continued with new construction and repair work into 2017. Alan and Kathryn Hughes, whose family owned the company since 1904, sold the premises, and its future use has not been announced. Negotiations were continuing in 2017 for the sale of the Whitechapel Bell Foundry Ltd for continuing manufacturing operations at another site.

Courtyard at Whitechapel Bell Foundry.

LAW AND ORDER 67

2ND HERNE

TREBLE HERNE

ABOVE *Early twentieth-century tuning forks, used when bells were tuned by hammer and a chisel.*
OPPOSITE *Casting bells for the parish church of Herne in Kent.*

HARROW SCHOOL

Harrow School, a boys' independent public school known usually just as 'Harrow', is located at Harrow on the Hill High Street, in north-west London. Although a school seems to have existed in the locale since 1243, it was not until 1572 that Harrow School was officially founded by a yeoman-farmer John Lyon, under a Royal Charter of Elizabeth I, and the schoolhouse was completed in 1615. One of the nine public schools reformed and regulated by the Public School Act (1868), Harrow usually has around 800 students, who live in a dozen boarding houses on a full-time basis, and whose school uniform features morning suits, top hats, straw hats and canes.

A roll call of celebrated alumni includes eight British Prime Ministers, including Palmerston, Baldwin and Churchill, and also Jawaharlal Nehru, the first Prime Minister of India, along with two kings, and members of both houses of the UK Parliament. The literary world is represented by Trollope and Byron, and Harrow School's theatrical talent includes Edward and James Fox, and Benedict Cumberbatch. Old soldiers include Field Marshall Alexander, as well as the 7th Earl of Cardigan (who disgraced himself at Balaclava), twenty recipients of the VC, and the entrepreneurial founder of Pret a Manger, Julian Metcalfe.

Harrow School's famous Fourth Form occupies the entire ground floor of the original seventeenth-century schoolhouse. The internal walls of the room are lined with moulded and fielded black panelling rising to a height of 7 ft (2 m), and, beginning with a T. Basil in 1701, generations of boys have carved their names into the wood. Standing in the middle of the west wall is a stone fireplace of the same era, with an

The Alex Fitch Room, built in 1918 with Elizabethan panelling and Jacobean furniture.

LAW AND ORDER 71

LEFT *Pupils' chairs in the Alex Fitch Room.*
OPPOSITE ABOVE *Rackets court. Harrow also has courts for squash and fives, and of course tennis. The school claims that squash was invented there some time after 1830, when boys discovered that a punctured rubber ball that squashed on impact produced a game with a great variety of shots. Rackets is a faster game, using a hard white rubber ball.*
OPPOSITE BELOW *The famous Fourth Form, with boys' names carved throughout, and birching block in right-hand corner.*
OVERLEAF *The Speech Room.*

eared surround, a central panel in the head and a cornice with carved brackets. Seventeenth-century chairs with flat-topped desks were positioned in tiers on both sides of the room, with a canopied Headmaster's seat at one end from where enthroned 'beaks' – teachers – could survey their pupils, while an usher seated in an armchair at the other end likely did his best to maintain order. On an outside wall is a plaque honouring the future Earl of Shaftesbury, who, the story goes, upon seeing a pauper's funeral, burned with 'shame and indignation', and was inspired to serve the poor and oppressed.

With so many former pupils undeniably associated with the uppermost levels of the British establishment, and its association with power and leadership, Harrow may seem a lofty hidden establishment, but it also has a human scale. Despite the magnificence of the panels, chandeliers, stained glass windows and Jacobean furniture of the Alex Fitch Room, a poignant story lies behind its creation. Alex Fitch was killed in the First World War at the age of nineteen, shortly after leaving Harrow. Given his happy days at the school his mother used the family wealth to construct a memorial in memory of her son. Initially, she suggested building an indoor swimming pool (a rarity at that time). Harrow, however, courteously declined, reportedly on the grounds her idea was a touch vulgar. Undeterred, Mrs Fitch proposed a grand room for entertaining, with that suggestion being accepted. Constructed from floorboards and wood panelling formerly from an Tudor ship, the room's serenity seems magnified by an aura of elegance from a bygone age. Stained glass windows depict Queen Elizabeth I granting the school's charter to John Lyon, while another window displays the arms of sovereigns who have been to the school, including those of Queen Victoria, who visited in 1848, and Queen Elizabeth II in 1971. But taking precedence over these monarchs is a portrait of the young Alex Fitch hanging above the stone fireplace. The light illuminating his portrait has never been extinguished.

In what is called Old Schools Building, the Old Speech Room was built between 1819 and 1821. By 1871, however, the school governors and headmaster resolved to celebrate the tercentenary of John Lyon's charter with the construction of a hall capable of seating entire school. Designed by the architect William Burges, the red brick building has a semi-circular shape whose straight eastern front runs parallel to the High Street. A north tower was added in 1919, before the attachment of a south tower in 1925, the bell of which summons the school to the chapel and the speech room. With its tiered seating, the room's interior resembles an amphitheatre, with a timber boarding ceiling, the vaulting of which is supported on pointed arches at the top of fourteen paired columns, decorated in red, blue and gold. The principal windows in the auditorium are grand in scale, with semi-circular heads and an intricate design of arches and roundels. The chamber's purpose was imbuing pupils with confidence through the art of public speaking, with many an aspirant orator later making his mark in parliament. As Lord Byron wrote of the Speech Room in his poem, 'On a Distant View of the Village and School of Harrow on the Hill': 'I once more view the room with spectators surrounded.'

LAW AND ORDER 73

10 DOWNING STREET

As executive residences go, a terraced house in a cul-de-sac is modest when compared to the White House or Élysée Palace, but measured in terms of continuous history, 10 Downing Street is hard to match. The Earl of Liverpool managed the Napoleonic Wars from here, Churchill was in residence to fight Hitler, and it was here that Thatcher took on the Argentinian military junta. How did a terrace become such a famous political address?

During the seventeenth century, George Downing, an Anglo-Irish jack-of-diverse-trades, abandoned his pulpit and chaplaincy for soldiering, became Cromwell's intelligence chief, and as Britain's ambassador to The Hague, expeditiously switched sides in time for the Restoration. Making his peace with the Crown, George acquired a knighthood, along with some marshland by St James's Park, and re-invented himself as a property developer. If the designs were Sir Christopher Wren, the houses were jerry-built on a bog, but George took a handsome profit and had the street named after him.

Decades later, with 5 Downing Street comprising two separate houses (later numbered 10), King George II presented the properties to Robert Walpole, First Lord of HM Treasury. Seemingly content with the splendours of Houghton Hall, his Norfolk country seat, Walpole suggested the houses be held in perpetuity for future holders of that office now known as Prime Minister. William Kent was hired to join both properties and rebuild their interiors, and three year's work produced sixty rooms with marble floors, pillars, fireplaces and crown moulding, and splendid views across the park;

The White State Drawing Room, containing works by J.M.W. Turner, with a view of the Terracotta State Drawing Room beyond.

the finished product cost a modest £20,000. With further building land required, a gentleman named Mr Chicken in an adjoining house was 'lent upon' to vacate.

Heads of state, from Assad to Zuma, have made their journeys to Number 10, as well as countless celebrities in arts and sports. For all, a tour of the house begins at the celebrated front door, once black oak, though armoured with blast-proof steel since a mortar attack by the Provisional IRA in 1991, but still retaining a lion head knocker and letter box whose inscription reads 'First Lord of the Treasury'.

The entrance hall's black and white checkerboard floor put in by Kenton Couse, Secretary to the Board of Works, during Lord North's tenure, complements the white fireplace used as a backdrop for photo calls, in which smiles and handshakes might suggest improved international relations. A more unusual hall furnishing is a hooded guard's chair by Thomas Chippendale. The ever-chiming longcase clock by Benson of Whitehaven so irked Churchill that he ordered its striking gear-train-operating bell-ringing mechanism silenced. If a portrait of Walpole overshadows other paintings, a small picture of 'Gorgeous' George Downing remains conspicuous.

By the foot of the central staircase stands an exquisitely crafted wooden globe gifted by François Mitterand to Margaret Thatcher upon the occasion of his 1984 state visit. Next, the Pillared State Drawing Room, the first of three inter-linked State Drawing rooms, is entered, often used for the signing of international agreements or for grand receptions. Double Ionic pillars stand at one end, reflected by Ionic motifs in the panelling and door surrounds, while a vast Persian carpet covers the floor. Between 1979 and 1990, a portrait of William Pitt the Younger hung above the fireplace, replaced, perhaps significantly, by one of Queen Elizabeth I only after Mrs Thatcher's resignation.

The Terracotta State Drawing Room's name changes to suit its colour. Once blue, Mrs Thatcher,

The coffin-shaped table in the Cabinet Room, which is cut off from the rest of the house by soundproof doors.

LAW AND ORDER 79

The State Dining Room, designed by Sir John Soane in 1827.

surprisingly, had it painted green, with Doric columns put in and a Palladian over-mantle fitted over the fireplace with the royal coat of arms above; discreetly carved in plasterwork is a gold-leaf straw-carrying roof thatcher. The White State Drawing Room contains Corinthian columns, ornate Baroque-style central ceiling mouldings and corner mouldings showing the four national flowers. It was used by Edward Heath as a music room.

The State Dining Room was built in 1827, and Sir John Soane excelled himself by designing a spacious chamber of oak panelling and reeded mouldings, where the vaulted arched ceiling rises to the second floor of the house. The Cabinet Room, all but unchanged over two centuries, is furnished with a coffin-shaped table, put in by Macmillan for a clear view of his ministers, and chairs used by Gladstone and Disraeli, while the grand triple staircase, lined with pictures

ABOVE RIGHT *The Terracotta State Drawing Room. Most of the room, including the overmantle bearing the royal arms, was remodelled in the 1980s by Quinlan Terry.*

of ex-PMs, sports a wrought-iron balustrade embellished with a scroll design and mahogany handrail. If Wilson, Thatcher and Brown used the study to work, Churchill preferred it for snoozing. Larry the Downing Steet cat is often in attendance, ever vigilant. If Campbell-Bannerman breathed his last in Number 10 muttering, 'This is not the end for me', this old terraced house – swiftly built and subject to subsidence, bomb damage and mortar attack, and threatened more than once with demolition – has, to date, survived all its Prime Ministers.

THE SUPREME COURT AND ROYAL COURTS OF JUSTICE

The positioning of the new UK Supreme Court, which started work on the west side of Parliament Square in October 2009, was functional and symbolic. Its distance from Parliament marked the separation of the judicial and legislative roles of the House of Lords. The full-time judges who were the Law Lords had done business in a warren of rooms in the Houses of Parliament; the Supreme Court justices who succeeded them were housed in a purpose-converted building which had once been Middlesex Guildhall.

At one time seven court rooms for Middlesex Crown Court and 100 cells were located here, but the conversion for the Supreme Court resulted in three court rooms, all without a dock, witness stand or jury room. In the Supreme Court, there is no prosecution or defence; appellants and respondents are represented by lawyers. The environment is 'designed to encourage an atmosphere of learned debate', according to the official profile. Judges and lawyers do not have to wear court dress, the proceedings are routinely filmed and all courts are open to public access when in session.

Court Room 1 was once Middlesex Council Chamber and retains a hammerbeam roof in the spirit of a medieval great hall. Courts 2 and 3 are original Quarter Session/Crown Court rooms. The Judicial Committee of the Privy Council works in Court 3 with jurisdiction over final legal appeals of thirty countries and territories in the British Commonwealth.

The Supreme Court is the final place of appeal in the UK for civil cases, and for criminal cases from England, Wales and

In Courtroom 1 of the Supreme Court, the original hammerbeam roof evokes a medieval hall; nine seats for nine of the eleven justices are seen here; usually, a panel of five judges hears cases.

LAW AND ORDER 83

84 UNSEEN LONDON

OPPOSITE *The Portland stone façade of the Supreme Court, with much statuary by Henry Charles Fehr; the central frieze depicts Henry III granting a charter to Westminster Abbey, flanked by King John with the Barons at Runnymede signing Magna Carta, and by Lady Jane Grey to the right.*

ABOVE *The Law Library in the Supreme Court is decorated with sayings from figures ranging from Ovid to Emerson, and on the glass balustrade here with quotations by Martin Luther King. The pop art carpet was designed by Sir Peter Blake.*

Northern Ireland. It hears cases of major public or constitutional importance – and can reject earlier rulings of lower courts.

Scottish architect James Gibson designed the building, which was completed in 1913. Architectural authority Pevsner called it Art Noveau Gothic, detecting a strong influence of Arts and Crafts style. When the Supreme Court plans were announced in 2006 there was some controversy from conservation groups because it was a rare example of a largely unmolested Edwardian interior, and the revisions proposed for the Supreme Court were extensive, most significant being a triple height galleried law library. In some places the result was a fusion between old and new, with original carved pew ends being restored and reused on new public seating. Public art was applied to the project, Sir Peter Blake designed carpets with symbols representing the four nations of the United Kingdom, letter sculptors provided carved quotes on screens and panels and the Japanese designer Tomoko Azumi designed the new courtroom furniture.

The Royal Courts of Justice on the Strand were planned and commissioned in the 1860s but construction did not start until 1873 and building work was spread over eight years, hampered by a change of site, labour disputes with stonemasons, financial crises and harsh winters. The building was opened by Queen

UNSEEN LONDON

Victoria in December 1882. These dates enable architectural historians to place the building right at the end of London's great Gothic Revival cycle, which produced the Palace of Westminster, St Pancras station, the Albert Memorial and numerous churches. The idea of a secular public building made to evoke a vaulted medieval gothic cathedral was becoming anachronistic, and the Royal Courts of Justice, widely known as the Law Courts, was the last in that tradition. Its most impressive feature, the Great Hall, is effectively a vast thirteenth-century nave.

Continuous expansion has been the underlying trend at the Law Courts and over the course of a century the rooms have multiplied. In 2017 signs in the building indicated courtrooms numbered past 100, and the total of all rooms exceeds 1,000. This required expansion into the basement areas and beyond, with the addition of whole new blocks. The first was the West Green Building, followed by the Queens Building, the and Thomas More Building. The separate Rolls Building nearby in Fetter Lane acquired in 1999 is also counted as part of the Law Courts. Despite the modern additions, the core of the Royal Courts remains close to its original state while restored, cleaned and updated in places. The ecclesiastical style is applied throughout, and except for the portraits and statues of judges, there is little to show that any of this is at the heart of a legal complex. In order to understand its purpose, it is necessary to enter one of the many of surrounding courtrooms during a trial, and in most cases visitors can do this.

The Royal Courts of Justice, designed as an instrument of modernization and reform, houses the High Court and the Court of Appeal of England and Wales. These handle high-level civil cases, divorce, property, inheritance, bankruptcy, company disputes, maritime law and certain criminal cases on appeal.

The Main Hall of the Royal Courts of Justice was inspired by a thirteenth-century cathedral nave.

BOW STREET MAGISTRATES' COURT

The building that was once Bow Street Magistrates' Court and Bow Street Police Station is scheduled for full rehabilitation as a hotel and museum. Bow Street Magistrate's Court became the most famous magistrate's court in England in the latter part of its 266-year existence. Its association with many high-profile arrests and cases means that it will always retain a peculiar notoriety.

All criminal cases must start in a magistrate's court and Bow Street's jurisdiction covered the West End, the South Westminster division of inner London. While Bow Street operated like any other magistrates' court, handling minor summary offences including driving, drunkenness and drugs, passing more serious indictable cases to the Crown Court, it will always be linked to the misfortunes of famous people, often in matters of power and pride. Bow Street also possessed a special jurisdiction in extradition matters, where the stipendiary magistrates heard applications by foreign states for the return of fugitives and suspects.

Oscar Wilde, arrested after the collapse of his own case against Lord Queensberry, was taken by detectives in a hansom cab to Bow Street and charged with gross indecency. Following an overnight stay in the cells on remand, he was removed to prison. Emmeline Pankhurst, arrested seven times, appeared for the first time at Bow Street (conduct subject to provoke a breach of the peace) in 1908. Dr Harvey Crippen, charged with the murder of his wife, stood in the same dock in 1910. Treason charges were brought against Sir Roger Casement in 1916, and William Joyce, nicknamed Lord Haw-Haw, in

Court One, where Oscar Wilde and Crippen were charged, showing lion and unicorn crest over the door.

ABOVE *Bow Street's distinctive doorway, a backdrop for countless celebrity photo opportunities.*
OPPOSITE *Row of eight Bow Street Police Station holding cells.*

1945. Philosopher Bertrand Russell was tried here in 1918 and 1961; on the second occasion, when he was aged eighty-nine, he had taken part in a demonstration in support of nuclear disarmament. Footballer George Best appeared at Bow Street charged with drink driving, as were the protestors who disrupted the 1970 Miss World contest. Under perpetual stakeout by news and picture agencies tuned to the daily court listings, hundreds of celebrity photo opportunities were found on the pavement outside Bow Street, followed by many desperate shots of a prison van emerging from the archway between the court and the police station.

The year 1968 saw the remand of the Reginald and Ronald Kray (conspiracy to murder) and a notable Bow Street extradition, James Earl Ray, Martin Luther King's assassin, who had fled to London. Extradition proceedings were also launched here against Chilean General Augusto Pinochet, who was destined to be excused a court appearance though ill health.

It is just possible to trace some historical connections to the first London law enforcement arm known as the Bow Street Runners, and to the novelist Henry Fielding, an early Westminster magistrate based here. In the mid-1700s Bow Street was home to a newly opened theatre, eight licensed premises, a poor house and a considerable number of brothels, which together generated a lurid reputation for lawlessness and licentiousness. More precisely, the court and police station

building at No. 28 Bow Street dates from 1879, a dignified Greco-Roman-style house faced in Portland Stone, built to the design of the public works architect Sir John Taylor and harmonizing with the imposing Royal Opera House opposite; the back of the building and the courtyard, which have now been demolished, always had a strictly functional brick-faced appearance. At one time the police station had sleeping accommodation for 100 officers on the upper floors. The magistrates eventually had three court rooms and there were separate series of cells for both the court and the police station. The court closed its doors in July 2006, after a low-profile case that of a man charged with breaking the terms of an anti-social behaviour order. The police station having closed in 1992, with the building remaining empty for years afterwards. The original wrought-iron dock from Court 1, where Wilde, Crippen and the Krays once stood, was removed and could most recently been seen in the National Justice Museum in Nottingham.

In a newly developed 100-bedroom Bow Street Hotel, planned to open in 2019, Court Room 1 will become the restaurant at its centre. Eight of the police holding cells, which are to be the part of the exhibition area of a police museum, are to be incorporated in the development.

92 UNSEEN LONDON

OLD BAILEY

The Old Bailey has a long and rather grim history, stretching deep into London's past. Officially, it is the Central Criminal Court, but it takes its popular name from the street in which it stands.

The current building, the third, replaced predecessors of 1539 and 1774, and occupies the site of the Newgate Prison, which in its various guises had incarcerated wrong-doers from at least the twelfth century. Newgate, which featured in many of the grimmer scenes of Charles Dickens' novels, was demolished to make way for the current court buildings in 1902. Some of Newgate's stonework was incorporated into the court building, and the thunderous knocker, from the prison door, was salvaged and preserved. A line of cells from Newgate still exists under the Viaduct Tavern, opposite the court, and they are occasionally open to the public.

The architect of the new building was E.W. Mountford, who died within a year of its completion in 1907. He produced a setting in which justice was not only done, but was also clearly seen to be done. The most distinctive emblem stands above the dome. This is a bronze figure of the Lady of Justice, who stands 195 ft (60 m) above the London streets. The sculpture, covered in gold leaf, holds a sword of justice in one hand, and a pair of scales in the other. Contrary to popular belief, she does not wear a blindfold.

The Old Bailey's function is further expressed at certain key points. Over the original main entrance, there is a powerful allegorical sculpture of Truth, Fortitude and the Recording Angel, above which is the inscription 'Defend the Children of the Poor & Punish the Wrongdoer'. The doorway leads

The view from the dock towards the judges' bench, in Court No. 1.

94 UNSEEN LONDON

LEFT *The ceiling of the Great Hall. Running around the frieze are the following axioms:*

 'The law of the wise is a fountain of life'

 'The welfare of the people is supreme'

 'Right lives by law and law subsists by power'

 'Poise the cause in justice's equal scales'

 'Moses gave unto the people the laws of God'

 'London shall have all its ancient rights'

ABOVE *A shard of glass remains preserved embedded in the wall at the top of the stairs, in remembrance of a Provisional IRA car bomb attack in 1973.*

to the Grand Hall, which is a riot of coloured marble and ornate decoration, including a series of vigorous murals and panels on the underside of the dome. Most of these paintings address the themes of Justice and English Law. The building was extensively damaged during the Second World War, and during its restoration some new murals were commissioned to celebrate the City of London's endurance in the Blitz.

Neither the entrance nor the Grand Hall are open to the public, though the proceedings of all four courts in the 1907 building can be observed via the visitors' entrance on Newgate Street. This is a grim doorway, set in a heavily rusticated granite wall that Dickens would have appreciated. Through it the visitor passes up a long flight of stairs and along a tiled corridor to the public galleries. The most sought-after seats are in Court No. 1, which is generally acknowledged as the most famous courtroom in the world. From narrow oak benches one can peer down to the scene of some of the outstanding trials in British legal history. A narrow staircase leads up from the cells into the glass-fronted dock, which has held defendants such as the murderers Dr Crippen (tried in 1910), the gangster twins Ronald and Reginald Kray (1969) and Peter Sutcliffe (1981). The dock stands at right angles to the jury and directly opposite the judges' bench, which is the most powerful feature of the court interior. There is accommodation for five judges, though the extra seats are usually occupied only on ceremonial occasions. The Royal coat of arms appears under a classical pediment, which is supported by four Corinthian columns. When the senior judge is sitting, the Old Bailey's sword of justice, dating from the sixteenth century, is displayed on a brass bracket behind him. Activity in the court is a curious blend of ancient and modern, as barristers and clerks, wearing wigs and gowns, employ twenty-first-century tools including laptop computers in this quintessential Edwardian setting.

A further twelve courts are housed in a 1972 extension to Mountford's Old Bailey. The two make uneasy neighbours, as the new building has a smooth, if remorseless, façade and cramped doorways, in contrast to the 1907 building's tough walls and grand entrance. The extension is,

however, recognized as a *tour de force* of internal planning, as the architects, McMorran & Whitby, successfully accommodated the requirement that the varied users – from judge and jury, to barristers, witnesses, defendants and the public – should not only each have a separate entrance, but be able to circulate through the building without coming into contact with each other at any point outside the courtrooms.

In addition to the Newgate knocker, the Old Bailey houses some unexpected historical artefacts. A section of Roman wall was discovered, and preserved, during construction of the 1972 extension, and a fragment of glass from an IRA car bomb which exploded in the street outside in March 1973 remains embedded in plasterwork above a staircase in Mountford's Great Hall.

OPPOSITE *The stairs leading from Court No. 1 down to the cells.*
LEFT *Dead Man's Walk, a legacy of old Newgate Prison, exists the under the Old Bailey, and this was the route that a condemned prisoner would follow from to the cell to the gallows. The archways become progressively narrower, designed to focus the mind: you are going one way and one way only.*

HM PRISON WANDSWORTH

Her Majesty's Prison Wandsworth stands in plain sight on Heathfield Road in SW18. Its squat twin towers of grey stone and false portcullis vaguely evoke a castle – in this case designed to keep those outside safe from those inside. It remains one of the biggest prisons in Europe. Its interior secrets are modest but fascinating, representing an unknown world for most people.

It dates back more than 150 years, being built on High Victorian principles. It was certainly not designed as a dungeon, and represented a great humane step forward from the horrors of cruelty and corruption in prisons such as the old Newgate, or transportation to Australia. From the start, Wandsworth provided each prisoner with a cell, water and lavatory – a facility that was withdrawn in 1870 when cell capacity had to be increased. In those early years, solitary confinement was the standard regime, no association of prisoners being allowed.

Wandsworth is often a described a 'Panopticon' prison, but that is at best only partly true. Panopticon design means that the prisoners can be watched constantly, or at least given the notion that they are being constantly watched. An observation point at a central position provides the prison officers with the ability to see all the cells, placed outwards from it and, ideally, kept in darkness. Jeremy Bentham, the English social reformer and philosopher, proposed the concept in the 1780s for the design of a national penitentiary for England, but his idealized design was hard to put into practice and it was never built. One of the earliest applications close to the Panopticon principle turned out to be the Eastern Penitentiary in Philadelphia, built in 1829. In this prison, the cells radiated in long galleries

The hexagonal central hall of HM Prison Wandsworth.

LAW AND ORDER

from a central hub, like spokes from a wheel. The first like this in England was Pentonville in 1842, with Wandsworth, designed by Birmingham architect Daniel Hill, following in 1851. The prison became HM Prison Wandsworth in 1878 as part of the first national prison service.

Wandsworth has a classic layout, comprising two main buildings with radiating three-storey wings. The largest building comprises five wings, A to E. The smaller three-wing building, originally for women prisoners, is the Onslow Centre, holding 330 prisoners. Wandsworth must accept all suitable prisoners from courts in its catchment area: South London and Surrey, and has a Category B security classification. Its maximum capacity is 1,665, having started with cells for 700 in 1851, the normal level of accommodation being 1,107, most being prisoners at the start of their sentences. The main buildings have never been extended. There are textile workshops operated by prisoners, including a carpet-recycling facility, a laundry and a small allotment garden with two greenhouses, and a formidable outer wall.

Around a quarter of British prison capacity in 2014 is in nineteenth-century buildings built close to the centre of cities. Many have struggled with overcrowding. Wandsworth, with its cell door observation hatches, thickly painted brickwork, ironwork stairs and landings, is typical. Viewed from central area, rather than from a cell, the overall visual effect is light and airy, but all these older prisons require high levels of property maintenance. Wandsworth has clearly made strenuous efforts to improve, after struggling through a patch when it gained the reputation of being the 'Hate Factory', and a scandal over the spinning of statistics by shuffling prisoners off to other jails

before official inspections. All wings have had in-cell sanitation since 1996 and in-cell electricity is installed throughout the prison.

Wandsworth still retains a grim legacy in several respects. There have been 135 executions on various gallows up until 1961, including the last man to be hanged in England for treachery, William Joyce, alias Lord Haw-Haw, in 1946. Ronnie Biggs the train robber escaped from here in 1965.

It is tempting to dismiss Wandsworth as a dinosaur, but there are no plans to close it, and the underlying elements of its design are still respected by prison officials. While the galleries themselves are antiquated, the latest prison designs call for 'optimal sight lines' for better utilization of staff and leaner manning. Some believe that the contact between prisoners and staff, and the safety of staff, is best in a radial prison.

Prisons from the 1960s have been built on T-shaped blocks, or with triangular layouts, not always successfully, but the accommodation blocks of Britain's newest prison, Oakwood in Staffordshire, consist of five arms radiating from a central point, quite recognisably similar to Wandsworth.

BELOW LEFT *Prisoners' gardens and allotments, where chickens are kept.*
BELOW *Prisoner's cell in E Wing.*

ARMY AND NAVY

IN MEMORIAM

1914 – 1919 1939 – 1945

HONOURABLE ARTILLERY COMPANY

An active regiment of the British Territorial Army, now properly known as the Army Reserve, occupies a remarkable patch of hidden green territory close to the City of London. The quaintly named Honourable Artillery Company (HAC) carries a fine array of regimental traditions, layers of history, and several armorial-heraldic distinctions. A complete profile of the HAC would fill a book, but the operational side of the regiment is straightforward. Its Army Reserve troopers are dedicated to the modern military arts of surveillance and target acquisition, using imaging equipment and weapons-locating radar. The sharp end of the HAC is represented by three patrol squadrons of trained reconnaissance soldiers, equipped to operate and survive behind enemy lines if required, and the selection process for the patrols is notably tough.

Attached to this function is a charitable institution, akin to a City livery company, sometimes known as the Company or House. This supports the active units and has its own civilian ceremonial organizations. Together, the active side (the Regiment) and the Company share a fine building, Armoury House, and the stretch of land in front known as the Artillery Garden. All this exists in E1, close to the noisy concrete roundabout at the end of Old Street, just off City Road, and enclosed to the north by Bunhill Fields Burial Grounds. Few who pass are aware of its existence. This is the London Estate, home of the HAC since 1641. Armoury House itself dates from 1735.

The first surprise for visitors to the HAC is the sheer expanse of Artillery Garden. Once used for archery practice, it is now a huge sports field overlooked by office buildings on the edge of the City. It has enough space for soccer, rugby and hockey pitches. There is a cricket square close to the spot where one of the oldest cricket pitches was laid in 1725.

The HAC was incorporated by Royal Charter in 1537. Within the infinitely baffling byways of British Army precedence, the HAC can claim to be the oldest regiment in the Army, while at the same time being the second most senior unit of the Territorial Army. It is also the second oldest military organization in the world (after the Vatican's Pontifical Swiss Guard). The word artillery is now misleading, for although the HAC has operated field guns, and still does for saluting purposes, across the centuries it has encompassed archers, grenadiers and infantry rifle companies. Today its active side includes a detachment of Special Constabulary to the City of London Police.

The Company of Pikemen and Musketeers are a purely ceremonial unit of the HAC, made up of veteran active members, and it serves as the bodyguard of the Lord Mayor of London on ceremonial occasions, primarily at Guildhall and Mansion House. It is armed and uniformed in the style of 1640, and the armoury houses their gleaming equipment, together with the instruments of the Corps of Drums. There is also a ceremonial HAC light cavalry troop, which acts as escort to the Lady Mayoress.

Armoury House retains many of its eighteenth-century features and is bristling with hardware and history. At the top of its Great Stairs, which are illuminated by a stained glass

PREVIOUS PAGES *Ceremony and function: saluting guns ancient and modern at the door of the Honourable Artillery Company.*

LEFT *The windows of the Great Stairs.*

106 UNSEEN LONDON

window, there is a battered stone pillar, known as a rover. This is an ancient archery target mark, reputed to be the only surviving example anywhere. It was removed in 1881 from a wall near a bridge over the Regent's Canal nearby. A ship's bell from the vessel that carried the 1st Battalion HAC to France in 1914 is preserved here. The panelled Long Room is lined with portraits of former captain generals and colonel commandants. In the Court Room sits the Court of Assistants, the board of governors for the HAC, who share the room with a rare example of sixteenth-century jousting amour.

Adjoining Armoury House is Finsbury Barracks. The two buildings are linked by a modern extension faced in striped stone and granite dating from 1994. Owned by the HAC, Finsbury Barracks is now administered by the Reserve Forces' and Cadets' Association. It was built in 1857 as the headquarters of the Royal London Militia, and from 1907 was the base of the Auxiliary Forces of the City of London. It dates from an age when the role of reservists and territorials was being developed, and drill halls were being built all across Britain. Finsbury Barracks remains a functional operational building leased back to the Army, and one of the memorable features of the HAC is seeing where pageantry ends and function begins.

OPPOSITE *A pair of wrought iron gates, installed in 1746, in the entrance hall at Armoury House.*
LEFT *The armoury.*
OVERLEAF *The Long Room laid out for the annual St George's Dinner, the Company's principal dinner of the year, held every April close to St George's Day.*

OLD ROYAL NAVAL COLLEGE

To understand the Old Royal Naval College at Greenwich the visitor must appreciate that it is not one building, but four. A fifth, which was originally crucial to its design, stands more than 330 ft (100 m) away, beyond a bustling main road. The remains of a sixth lie embedded among the foundations of one of the main college buildings.

To add to the confusion, the best place to view the college is not within its boundaries but on the far side of the River Thames. This vantage point was used by Canaletto to produce a classic painting of the college soon after its completion in 1752. From here, the enigma of Greenwich resolves itself into one of the glories of English architecture. The four key blocks, named after Queens Anne and Mary and Kings Charles and William, frame that fifth regal building: the Queen's House.

The college's origins date back to 1694 with the foundation of a Royal Hospital for Naval pensioners who, in the motto of the hospital, were 'safe moor'd in Greenwich tier'. In 1873 the buildings became the Royal Naval College, for research and the training of officers. Today, the buildings, centrepiece of the Maritime Greenwich World Heritage Site, are occupied by Greenwich University. The government's decision to sell the college prompted a debate in the House of Lords, during which one noble speaker insisted, 'If there were a designation of buildings as Grade I triple star, these would qualify, both on historical and on architectural grounds.'

All of this is the work of not one architect, but many. Sir Christopher Wren takes most of the credit, planning four new buildings to respond to the much older Queen's House, completed in 1637 by Inigo Jones. Wren laboured under three key conditions: he was to retain the shell of a palace started

Inside the clock tower of the Queen Mary building, Old Royal Naval College.

ARMY AND NAVY 111

LEFT *Under the King William building is this skittle alley, a relic of the Royal Hospital for Greenwich pensioners, who once enjoyed fierce after-dinner contests here using practice wooden cannon balls as bowling balls.*

OPPOSITE ABOVE *The undercroft is the only surviving part of Greenwich Palace. Henry VI called the palace L'Pleazaunce or Placentia, from its agreeable location. It was the principal royal palace for two centuries, and Henry VIII, Mary I and Elizabeth I were all born here. Neglected, it was finally demolished by Charles II.*

OPPOSITE BELOW *Twelve stone heads depicting Poseidon, the sea nymph Galatea and lions, originally intended to decorate the exterior of the Painted Hall, which had been designed with a Portland stone cladding. When financial cuts caused the building to be finished in brick they were not mounted. Many of the fifty-seven heads carved by Robert Jones survive in the undercroft of Queen Anne building.*

but not finished by Charles II; he was not to obstruct the view of the river from the Queen's House; and the result was to be magnificent.

Wren's skill lay in turning the problems into a solution. So Charles II's half-built palace was absorbed into what is now the King Charles building, which is on the right, nearest the river, as one looks from Canaletto's viewpoint. Wren designed a companion to the King Charles building, the Queen Anne building, with the Grand Square between them. Further back from the river, he produced the more ornate King William and Queen Mary buildings, each crowned by a spectacular dome. The Queen's House, which lies on the line dividing the four blocks, thus not only had its view of the river preserved, but became the focus of what one Wren biographer called 'the most distinguished group of buildings in England'.

There is, however, a disparity between the grandeur of Wren's work and the relative plainness of the Queen's House, which makes it an unlikely, if distinguished, climax to the composition. Sir John Summerson, one of Britain's most respected architectural historians, therefore described the domes as 'two cats looking at each other in the absence of a king'.

Beneath those domes, the William and Mary buildings contain the college's most celebrated interior spaces: the Painted Hall and the Chapel, respectively. The Painted Hall, the grand dining room of the original hospital, is among the contributions of yet another distinguished architect, Nicholas Hawksmoor, who served as Wren's assistant. It was decorated, in nineteen years of stop-start labour, by Sir James Thornhill, who produced a fervent Protestant celebration of Britain's maritime power and prosperity.

The Chapel is a calm and reflective contrast to the Painted Hall, though this is not the original interior, which was destroyed in 1779 by a fire that broke out in a tailor's workshop below. The present chapel, of 1789, is the work of James 'Athenian' Stewart, one of the eighteenth century's finest neo-classical architects.

Under the Queen Anne building, a few dozen metres away, are the remains of the sixth building: the Tudor palace of Placentia. This was the birthplace and riverside playground of Henry VIII, which fell into decay and was mostly demolished by Wren. Its crypt survives, and archaeologists have traced more of its plan beneath the Grand Square.

Almost nothing remains to reflect the lives of the thousands of sailors who lived out their days as Greenwich pensioners, though their skittle alley has survived intact beneath the King William building. The King William block also has the unique distinction of being the only seventeenth-century building ever to house a nuclear reactor. It was home to a small training reactor used by the Royal Navy between 1962 and 1996, now dismantled. The Navy left finally in 1998, but on Trafalgar Night, groups of men, their chests heavy with medals, may be seen strolling after dinner in the grounds of the Old Royal Naval College. The heart of the Navy remains safe moor'd at Greenwich.

ARMY AND NAVY 113

114 UNSEEN LONDON

HORSE GUARDS AND HYDE PARK BARRACKS

The Household Cavalry Mounted Regiment, assigned to protect the Sovereign, can be seen at two places in London. Hyde Park Barracks are on the southern side of the park, about a mile from Buckingham Palace. The other location is Horse Guards, which is a building rather than an organization, facing Whitehall and closer to the Palace.

The bases and barracks of the British Army have always been easier to describe than its regiments and roles. In 1990, following the Army's endless tradition of amalgamation, the Life Guards (LG) and the Blues and Royals (RHG/D) became the Household Cavalry (HCav).

The Household Cavalry is itself made up of the Household Cavalry Regiment (HCR) and the Household Cavalry Mounted Regiment (HCMR). The operational role of the HCR in combat is reconnaissance, while the HCMR, comprising from a squadron each from the Life Guards and the Blues and Royals, combines ceremonial functions alongside an internal security role.

Despite amalgamation, each regiment has been allowed to retain its separate identity, regimental headquarters, uniforms and accoutrements. The Life Guards, the senior regiment in the British Army, with a Royalist history, has amassed battle honours from Waterloo to Basra. The Blues and Royals, formed in 1969 by a merger of the Royal Horse Guards (Blues) and the Royal Dragoons (1st Dragoons), can trace their lineage back to the New Model Army; battle honours span the Peninsular War, Balaclava and the Falklands.

The stables of the Queen's Life Guard at Horse Guards.

Horse Guards, where the permanent protection for the Queen is positioned, is a Palladian-style Grade I listed building between Whitehall and Horse Guards Parade. The current structure was built between 1751 and 1753 on the site of the former tiltyard (jousting courtyard) of the Palace of Westminster. A strange feature is the double-sided clock high over the archway, with two o'clock on its face marked with a black disc, said to commemorate the hour of execution of King Charles I in 1649 at the Banqueting House opposite.

Most of the ground floor here consists of stables that can accommodate 108 horses in restricted movement stalls, each with a feed-rack. The 'Cavalry Blacks' – traditional crossbreeds of the Irish draught and thoroughbred – are predominantly black touched with white markings. Other breeds include greys for trumpeters, all-black officers' chargers and drum horses. These are usually shires and Clydesdales, which can stand as high as nineteen hands, and are selected and trained to carry heavy solid silver kettledrums.

Guard is provided on alternate days by the Life Guards and the Blues and Royals. Two dismounted sentries are on duty until the gates are shut at 2000 hours, after which just one sentry remains until 0700 hours; once the gates are closed, no one, unless in possession of the password, can gain admission to Horse Guards. A guard changing ceremony – properly called Guard Mounting – is a daily event held at 1100 hours and 1000 hours on Sundays, lasting for thirty minutes.

The HCMR's main base is Hyde Park Barracks, formerly known as Knightsbridge Barracks, a name frequently still used. Barracks have existed on the site since 1795, but the current modern buildings were designed by architect Basil

Spence and date from 1970. An accommodation tower block, called Peninsular Tower, controversial in its time, dominates. The barracks has its own a smithy and almost 300 horses are maintained in extensive stables on two levels, with ramps electrically wired to de-ice the surfaces.

The Dress Store at Hyde Park is filled with traditional and exotic military clothing. A drum major's state dress for the Sovereign's birthday parade (Trooping the Colour) includes a gold and heavily embroidered tunic the design of which dates from the Restoration, as do dark blue velvet jockey hats for musicians. Solid silver drums, weighing 66 lb (30 kg) apiece, are carried by the drum horses, which traditionally are named after Greek mythological heroes. Life Guards wear their chinstraps beneath the lower lip, while Blues and Royals wear straps beneath the chin. A holder on a helmet's pinnacle supports a faux horsehair plume, white plumes for Life Guards and scarlet for Blues and Royals. Tunic colours are red for the Life Guards and blue for the Blues and Royals. A polished steel breast and back plate called a cuirass is worn for mounted duty.

In July 1982, members of the Provisional IRA detonated a large nail bomb during a Changing of the Guard procession from Hyde Park Barracks to Buckingham Palace. Three Blues and Royals soldiers were killed outright, with a fourth dying within three days from his injuries. Other troopers sustained serious injuries, as did several spectators who were peppered with shrapnel, while seven horses were killed or subsequently put down because of injuries. When passing the site of the bombing, soldiers bring their swords down from slope to carry, combined with an eyes left or an eyes right, as a sign of respect.

OPPOSITE *A Blues and Royals mounted guard at Horse Guards.*
LEFT *The forge at Hyde Park Barracks*

ROYAL HOSPITAL CHELSEA

The Royal Hospital in the London Borough of Kensington and Chelsea, designed as a retirement and nursing home for some 400 English soldiers unfit for duty because injury or old age, opened in 1692.

The medieval tradition of monastic care for disabled and maimed soldiers had been destroyed by the Reformation. Parliament debated the health and rehabilitation problem for more than a century without any satisfactory conclusion, despite the demands inflicted by bloody conflicts, which included the English Civil War. It was not until the reign of Charles II, with the establishment of a regular army, that plans were implemented. There is a legend (with no supporting evidence) that the hospital was suggested to the King by his long-term mistress, the 'orange wench' Nell Gwyn.

What is clear is that the concept of a military hostel-hospital was inspired by Les Invalides in Paris. Sir Christopher Wren was commissioned as architect. The architectural scale and scope of the Royal Hospital was, for the 1680s, hugely impressive, and today it is viewed as a Wren masterpiece.

Running parallel between the Thames and the road from Chelsea to Westminster, the four-storey dark-red brick edifice contains a huge dining hall and chapel separated by a vestibule crowned with a central cupola. There are red brick window dressings, and a central portico supported by four Doric columns whose pediment is pierced by a central clock.

The entrance to the Christopher Wren chapel.

The hospital's vestibule or entrance, standing between the Great Hall and the chapel, is octagonal in design, while the octagon itself supports the hospital's cupola and lantern, which rises to a height of about 130 ft (40 m). The vestibule is lit by a large south window above the doorway, along with the upper lantern, allowing so much light in that the area glows like a candlelit cathedral.

That main building and its two corresponding wings combine around three sides of the hospital's great open quadrangle, while many acres of parkland sweep down towards the Thames. Adjoining this central group there are smaller two-storey buildings exuding an aura of rural domesticity. Here is a cloistered walk giving access to side courts while trapping the benefits of sunlight for the old soldiers.

The state apartments consist of two main rooms: the Council Chamber and the Anteroom. The Council Chamber, an oak-panelled room designed by Wren and embellished by Robert Adam, was designed as a dining room for visiting dignitaries.

OPPOSITE *The Great Hall's west wall is dominated by a painting of Charles II on horseback surrounded by allegorical figures, executed by Antonio Verrio and completed by Henry Cooke; captured colours displayed along the side walls include French, Dutch and American flags.*

LEFT *A bronze one-and-a-half life size statue of a Pensioner, commissioned by the Royal Hospital for the millennium, depicts an old soldier in a three-quarter length coat, adorned with campaign medals, and a tricorn hat. His right hand holds a walking stick raised in defiance of the world, his left hand clutches an oak branch referring to the Battle of Worcester (after which Charles I took refuge in an oak tree).*

In the apartments are a painting of Charles I and his family, attributed to the school of Van Dyke, and portraits of Charles II, Queen Catherine, James, Duke of York, the Earl of Ranelagh, Sir Stephen Fox and Sir Christopher Wren are by Kneller, Lely and Van Dyke himself.

The ceiling of the chapel is a semi-circular barrel vault of creamy white plaster divided into geometrical sections, whose elaborate stucco ornaments comprise fruit, flowers and cherubim. The walls are punctuated with high semi-circular windows, the floor is laid with black and white diagonal squares and the Corinthian-style Irish oak altar screen is attributed to Grinling Gibbons. A large gilded cross adorns the altar as do a fine pair of gilt candlesticks, and a mahogany pulpit looks down at a congregation that might number up to a few hundred.

The Great Hall, the Royal Hospital's biggest room, is used as a communal dining facility for the Chelsea Pensioners. Its many paintings include portraits of Sir Christopher Wren, Queen Victoria and the Duke of Wellington.

ABOVE *The Council Chamber – designed by Wren, embellished by Robert Adam – exhibits top artistry and craftsmanship: a heavily moulded ceiling, displaying James II's cipher, is the work of the master plasterer John Grove, the wainscoting was produced by joiner William Cleere and the lime wood carving above the fireplace is by leading woodcarver William Emmett.*

OPPOSITE *The octagonal ceiling of the vestibule rises into an eight-sided dome, with cupola and lantern.*

At the centre of Wren's original architectural design lies an area called Figure Court, and this is the oldest part of the Royal Hospital. Bordered by the state apartments, chapel and Great Hall, the courtyard space is dominated by a statue of Charles II that was presented to the King in 1682.

Nearly all the buildings at Chelsea that gain attention today were designed by Wren, but that was not always the case. Just over a hundred years after the hospital was built, Sir John Soane was appointed Clerk of Works and this distinguished architect designed several new buildings, including an enlarged infirmary, as the Royal Hospital grew to keep pace with the demands generated by the Napoleonic Wars. Soane's infirmary fell victim to a V-2 rocket in 1944 and has been twice since been supplanted by modern buildings. The full extent of the Wren garden, which once went down to the river, cannot be appreciated since the creation of the Chelsea Embankment.

SECRET MILITARY BUNKER, CODENAMED 'PADDOCK'

Some of London's most secret government and military sites turn out, on declassification, to have barely been used. A leading example is the underground bunker codenamed Paddock at Dollis Hill in north London. It was built at the start of the Second World War as a contingency against the destruction of the main Cabinet War Rooms in Whitehall, but it appears that there was never any operational cause for ministers to deploy there. It was occupied by staff only twice, in brief exercises lasting for a couple of days.

On one of those occasions, 3 October 1940, it was visited by Prime Minister Winston Churchill in what he described as a 'dress rehearsal' for Central Government War Headquarters dispersal. This was the high point of its melancholy, dust-gathering seventy-year history. Churchill had a considerable aversion to austere secret buildings, and described Paddock as 'a useless piece of folly'. He did not believe that the Cabinet could ever work there. By contrast, the main Cabinet War Rooms in central London were used more than a hundred times during the war. The Prime Minister, who enjoyed creature comforts, preferred the luxury of Downing Street close by. At Paddock there was no accommodation, and the dispersal plan was to house the Prime Minister and staff above ground in Neville Court, a requisitioned block of unfortified civilian flats in a nearby suburban street. The logic of this is hard to fathom.

Paddock was excavated in secrecy alongside the Post Office Research Station at Dollis Hill, a massive office and laboratory block. A late decision about the dispersal of key sites had launched construction in the grounds of the Dollis Hill site in 1939, and Paddock was completed a few days before the start of the Battle of Britain in June 1940. When Paddock was conceived, there seemed to be a compelling need for it. Expert studies, based on the notion that 'the bomber will always get through', had anticipated complete destruction of vast areas of central London in any forthcoming war.

It was a three-level structure, with basements 40 ft (12 m) below the surface. Thirty-seven rooms in all were built along central spines, including offices for the Cabinet, a map room, teleprinter space, possibly a broadcast studio and a private office for the PM. The surface building for Paddock has been demolished, but two of the three original entrances remain, one of which now lies incongruously at the end of a garden between two private houses. Underground, many of the rooms and the diesel-powered emergency generating and ventilation plant remain intact, but derelict. Massively engineered entrances, which once held blast doors, can be seen, but the thick concrete slab ceilings for both basement levels are now concealed.

It was called Paddock merely because that word appeared on a randomly compiled list of non-descriptive codenames. After the Churchill visit, just one further meeting was conducted there: a presentation given to impress the visiting Australian Prime Minister Robert Menzies in March 1941.

The generator room.

As it emerged that the bunker was unlikely to be used, much equipment was moved out to other sites. Only a skeleton guard of Army personnel remained. Paddock was officially closed in late 1944, even as V-2 rockets descended on London.

Above ground, in the main Post Office building at Dollis Hill, a far more profound contribution to the conduct of the war came in the form of the first programmable computer, designed and constructed by Post Office engineer Tommy Flowers. This was Colossus, destined for Bletchley Park for crucial code-breaking duties. It is said that some of the prototype circuit boards for the Colossus were stored in the Paddock rooms for years afterwards, but the Post Office did not make much significant use of the underground facility.

Although a new series of secret buildings were developed in Britain after 1949 for Cold War use, no subsequent use was ever found for Paddock. It had been designed around comparatively vulnerable manual and electro-mechanical communications systems with surface landlines. Later, cable tunnels were driven deeper in central London and the telecommunications links were made tougher. But Paddock remained a well protected bunker, at least, and local authorities were charged to find sites for regional seats of government and other secret facilities in the age of nuclear war. As late as 1981 there was a suggestion that Paddock might be revived as a war room, but the Greater London Council found that water seepage had taken its toll on the lower basement. Telecommunications research at Dollis Hill had ended by 1976 and the main Research Station building was converted into apartments. A housing association acquired the rest of the site, and developed new homes where the bunker surface building once stood. Paddock bunker is listed, preserved and maintained, and has recently been opened to visitors on one or two occasions each year.

RIGHT *The lower spine corridor.*

OPPOSITE *The emergency staircase.*

OVERLEAF *The emergency staircase from below.*

ARMY AND NAVY 127

IN AND OUT CLUB

One of central London's most distinctive landmarks, the Naval and Military Club's former home on Piccadilly, is in the process of tracing an historical arc that may yet become a full circle. It began as an extremely wealthy aristocrat's London home in 1761, and later became the residence of a serving Prime Minister. For more than a hundred years it was used by the Naval and Military Club, better known as the In and Out, after the signs on the entrance and exit gateposts. It has recently gone through a decade of disuse, and now looks set to become the most expensive private residence in modern London. In 2014 No. 94 Piccadilly stood empty, but was poised for a fresh life, after its property company owners had gained permission to turn it back into a single dwelling: ideal for someone comfortable with forty-eight rooms and a price tag of a quarter of a billion pounds.

Of all the former occupants of 94 Piccadilly, the 1st Duke of Cambridge had the highest status, and for this reason the property is known as Cambridge House. Lord Palmerston later bought the house and lived there during his term as Prime Minister. After his death, the lease of Cambridge House was acquired by a fast-growing service club recently formed by young officers, who were looking for larger premises. The Naval and Military members soon commissioned extensive changes, including a portico and a large dining room. Re-opening on St George's Day 1878, Cambridge House remained in the hands of the In and Out Club for more than 130 years. Former members have included T.E. Lawrence and Ian Fleming. In recent years membership was expanded to include those who had not served in the armed forces.

Even by the standards of Victorian clubland, the In and Out on Piccadilly was a lavish establishment. It was less cramped in scale and outlook than many of the older clubs just off the pavements of St James's, with a view over Green Park and an expansive driveway entrance. Its location is classic, sitting right on the border of Mayfair and St James's.

After the lease on 94 Piccadilly expired, the Naval and Military Club moved to a new home in St James's Square in 1999, and the building came into the possession of an entrepreneur, who planned to turn it into a hotel and a members' club along modern lines, with a swimming pool beneath the forecourt and extensive sports facilities underground. Those plans did not develop and the ownership changed again, going to the real estate company of David and Simon Reuben.

In 2014 the interior remained largely intact but unfurnished, showing the features of the renovation-conversion of 1876–8,

The Long Corridor dates from the time of the house's conversion to a clubhouse.

which had made the house into a club. It is a glimpse of old clubland, with a now-tableless billiard room and an old-fashioned porter's lodge, unattended but ready to be brought to life by a loyal club servant. The smoking room, the enlarged dining room and an elegant long corridor on the first floor all date from this time, along with the extensive wine cellar. Restoration of Cambridge House to a residence would aim to retain many of these features, and would take three to four years.

Cambridge House has had no other purpose than a clubhouse in anyone's memory, and it is hard to imagine it reverting to residential use. When Charles 2nd Earl of Egremont commissioned the house in 1761 he used it as his London home. Piccadilly was a smart residential area then, and only became a mainly commercial area after 1945, with car dealership showrooms, offices, hotels, an embassy and several corporate headquarters lining the street. More than one property specialist based in Mayfair has reported that the balance may be shifting back in favour of old buildings becoming houses again, including Cambridge House. Houses are worth more than offices.

BELOW *The tableless billiard room, awaiting renovation.*
OPPOSITE *The first floor has the main reception rooms for entertaining, as in all major houses of the period.*
OVERLEAF *The porter's lodge, typical of nineteenth-century clubland.*

THE OLD WAR OFFICE

The Old War Office on Whitehall, after serving for more than a century as a forbidding military administration headquarters, is poised to become a complex incorporating a hotel and a range of apartments. By 2020, this classic Edwardian baroque building is scheduled to emerge with 125 bedrooms, 88 apartments for permanent residents, pool and spa, cinema, gym and library. Although the interior will be transformed, the developers are working to a tough specification which requires these changes to be all but invisible from any street-level aspect. Hinduja Group is working with co-owners OHL Desarrollos and the plan is to retain the spirit of building while improving features such as the harsh glazed brick lightwells and exploiting the many windowless spaces. The pictures here show the original interior just as the construction work started in 2017.

When completed in 1906, the War Office at 57 Whitehall joined an advance of Government buildings that marched the length of the street. At one time the Palace of Whitehall had existed there, a straggling collection of buildings that once stretched from St James's Park down to the river, and mostly lost in a fire of 1698. There had been splendid private mansions too, but nearly all surviving buildings were swept away as the growing apparatus of state demanded more offices. The War Office was a prime modern example, massive in its day with two and a half miles of corridors. Built just before steel-frame construction became widespread, its walls are reputed to comprise 25 million load-bearing bricks under thousands of tonnes of Portland and York stone. There is no precise count of the number of rooms, estimated at around

The main staircase, Old War Office.

The Army Council Room, where the First and Second World Wars, and Iraq Wars, were planned.

1,100. Inside, a strict hierarchy once existed, running front to back from the grand hall and opulent Italian marble main staircase. A legend of the War Office was that only Field Marshals and cleaning ladies were ever seen on the staircase. The principal rooms, including the office for the Secretary of State for War, and the Army Council Rooms, are close to the stairs on the second floor, and are panelled and fitted with marble fireplaces. Lesser, barer offices were disposed into the far recesses across seven storeys and two basement levels.

In one of these rooms in late-1914 a civilian named T.E. Lawrence, soon to be commissioned as second lieutenant, toiled to produce a large-scale map and guide of Sinai in a sub-department known as MO4, the geographical section. It then housed departments ranging from Military Operations and Military Intelligence to the Directorate of Remounts. The War Office in 1914 became the most compelling department of state, and the leading political figures served as Secretaries of State, Asquith, then Kitchener, the only secretary to serve in uniform, then Lloyd George, followed by Churchill.

Viewed from Whitehall the Old War Office seems to present a symmetrical face, but a walk around reveals no side is parallel to another. The ground plan was dictated by surrounding buildings and roads. Some of this strangeness of shape is disguised by the four domed corner towers. These and the rooms directly beneath are identical, while the lobby rooms just inside are each of different sizes to resolve the difference. The War Office has four entrances; as well as Whitehall, there is the staff entrance at Whitehall Place, a vehicle gate

Entrance to the Old War Office courtyard.

on Horse Guards Avenue and the door known as the spies' entrance on Whitehall Court, just a few paces across the street from the Secret Intelligence Service Headquarters of 1911.

At the close of the war there were 7,434 civilian staff – in the Whitehall building and elsewhere – but this had declined to 3,872 by April 1930. The late 1930s saw the fitting of steel reinforcing beams in the basements for bomb protection as war loomed again.

In 1960 John Profumo was appointed Secretary of State for War. His wife, the film and stage actress Valerie Hobson, supervised the redecoration of his office in blue and white paint on the wooden panelling. With the paint removed today the woodwork in the room shows a lighter tone. Profumo, who resigned in 1963, was not quite the last Secretary of State for War, but the post was abolished the following year, when the War Office, Admiralty and Air Ministry were combined to form the tri-service Ministry of Defence. From then the nameplate on the door bore the title Old War Office building. The building continued to serve, although the Ministry of Defence Main Building across the road housed most departments. When the Main Building required extensive refurbishment, personnel were 'decanted' into the Old War Office, which was fully functioning and operational at the time of the second Gulf War in 2003. One of the last organizations to be housed there was the Defence Intelligence Staff but by 2013 most of the building was empty and is was sold to the developer in March 2016.

THE FOURTH ESTATE

ABBEY ROAD STUDIOS

Extravagant claims are made about Abbey Road Studios. It is said to be the first studio to be purpose-built for making records, and the largest music recording studio anywhere. It is said that stereo was invented here. Abbey Road is also said to be the most famous recording studio in the world, and that claim is hard to challenge.

Leading artists in every field of music and entertainment have recorded here. Sir Edward Elgar opened the studio in 1931, and then conducted the London Symphony Orchestra for a recording of the Pomp and Circumstance Marches. Pablo Casals recorded Bach here in 1936, and Paul Robeson cut records at Abbey Road throughout the decade. The last recordings by Glenn Miller leading the US Army Air Force Band were made here in October 1944. Great jazz musicians, popular singers, comedy performers and the most famous pop and rock artists have all worked at Abbey Road. The roster is almost incongruous: Shirley Bassey and Gracie Fields, Yehudi Menuhin and Cliff Richard. Abbey Road Studios remains active in all musical fields. From 1980 it added orchestral film score recording, including the soundtracks of *Raiders of the Lost Ark*, *The Empire Strikes Back*, *Shrek*, *Harry Potter and the Philosopher's Stone*, *Skyfall* and *The Hobbit*.

EMI – Electric and Musical Industries – can claim most of the credit. Rooted in the earliest recording companies, EMI was formed in 1931 with merger of the Gramophone Company and the American company Columbia Graphophone, which also bought with it the Parlophone label. Work had already started on making a recording studio before the merger. This

PREVIOUS PAGES *Studio 1 can accommodate the largest orchestras and is much used for film score recording.*

RIGHT *Studio 2 is the inner sanctum where The Beatles recorded mostly, George Martin producing.*

THE FOURTH ESTATE 143

had required a visionary leap, because at the time all music recording was made in concert halls. No. 3 Abbey Road, St John's Wood, is a 'handsome if unremarkable villa of the 1830s', according to English Heritage. It was redesigned by architects Wallis, Gilbert & Partners, which specialized in factories.

One of the riddles of Abbey Road for those who make the pilgrimage there is how a converted nine-room townhouse can accommodate so much recording space, in particular the massive Studio 1, capable of holding 110 orchestra musicians together with a choir of 100 singers. The secret is that Studio 1 is a vast brick box, engulfing the entirety of what used to be the back garden, at full width. It resembles a film studio rather than a recording space. Studio 2, at a lower level to the side, is where The Beatles recorded most of their music. Many recording spaces are reputed to have particular sonic magic embedded in the fabric, and insiders talk of the EMI echo, or reverberation, in Studio 2, and other qualities of great subtlety. A Second World War air raid shelter at the back of Studio 2 was converted into an echo chamber. Studio 3 is a more intimate space for instrumental soloists and singers, and today there is also a penthouse studio.

Some of the mythology of Abbey Road Studios stems from EMI's artists and repertoire department over the years, both with British and European musicians, and through its transatlantic links and partnerships – in particular, the decision to record The Beatles on EMI's Parlophone label. From 1962, the band cut 190 of its 210 recordings at Abbey Road.

Additional significance rests on a ten-minute photoshoot on 8 August 1969, when photographer Iain Macmillan shot six pictures of The Beatles walking over the pedestrian crossing just to the left of the studio entrance. One image was selected for an album cover. Twelve days later all of The Beatles worked in the studio together for the last time and Abbey Road was the name assigned to that final recorded album.

One minor mystery is the precise date when EMI Studios

officially became Abbey Road Studios. All musicians of the 1960s, including The Beatles themselves, invariably referred to the studios simply as 'EMI', and never as Abbey Road. Although Abbey Road's iconography was undoubtedly launched by the cover picture and naming of The Beatles' album, the sign on the entrance door transom changed only in gradual stages over the next ten years. Still tagged EMI Recording Studios in 1971, then changing to EMI Abbey Road Studios, at a later point it became Abbey Road Studios. Some in the music industry say a shrewd rebranding came at a time when the power of the recording companies was declining, as bands and producers grew more powerful. If so, Abbey Road was a masterstroke in charismatic renaming.

A tiny hard core of female Beatles fans haunted the entrance of the studio for the years when the band was active there; what has happened since is harder to understand: an estimated quarter of a million tourists each year travel to Abbey Road Studios (which does not allow visitors inside), endowing it with shrine status and one of the most graffiti-decorated walls in London. As visitors regularly recreate the Abbey Road moment on the pedestrian crossing, it can sometimes prove hazardous.

English Heritage, in outlining the listed status of Abbey Road and the crossing, acknowledges 'the sheer cultural status of the premises'.

TOP LEFT *Working condenser and ribbon vintage microphones. Part of a collection of 500 still in use today.*

TOP MIDDLE *Studio 1 control room's centrepiece is a 72-channel console; all analogue and digital formats are supported in the studio.*

TOP RIGHT *The pavement wall, decorated with messages from visitors around the world, is regularly painted over.*

TELEVISION CENTRE, WHITE CITY

BBC programme-making resumed at Television Centre in 2017 after a short break. Less than five years had passed, and during that time the complex at Shepherd's Bush was transformed. Studios were now surrounded by a growing array of newly built apartments, soon to be joined by offices, shops, restaurant and a club hotel. After the Corporation sold the site to property developers Stanhope in 2012, it came back with the status of leaseholder on three studios. These are operated by BBC production facilities arm Studioworks, while the commercial part of the corporation, BBC Worldwide, now occupies offices where the news centre once stood.

It was a symbolic moment when the distinctive BBC signature block signage was lowered from the façade, but truly the end of what was known as The Television Factory, and there will never again be a purpose-built facility so comprehensively responsible for television. Over fifty-three years BBC Television Centre handled drama and light entertainment, music, news presentation and sport broadcasting and housed most of the technical facilities in support, from engineering and scenery construction, to dressing rooms and catering.

Television broadcasting from Alexandra Palace between 1936 and 1939 established the BBC as television pioneer, but that era was a kind of pre-history, almost a false start. When the BBC returned to television broadcasting after the Second World War, it knew from its experience at Alexandra Palace that bespoke studios were essential, and wrote a requirement for a specialized building. Land for BBC Television Centre was acquired in 1949 at a disused exhibition site in Shepherd's Bush. The scope and scale of what was destined to be the

The statue of sun god Helios by T.B. Huxley-Jones, with fountain beneath.

THE FOURTH ESTATE 147

148 UNSEEN LONDON

largest television studio building in Europe required that it be planned in phases.

It was a tough specification, made more difficult by being launched in an era of rationing and austerity. The first construction took place in 1950 and 1951, but a squeeze on government funding and restrictions on the licensing of scarce materials stopped work for two years. Construction restarted and the official opening of the first studio came in 1960, while work continued for years afterwards as more studios were added up to 1998.

Legend has it that architect Graham Dawbarn, who had been given a fifty-page brief by the Controller of BBC Television Service, sketched the outline on the back of an envelope based on a question mark he had doodled. The envelope and drawing certainly exist, and the postmark is December 1949, but recent research has tended to suggest is not the first rendering. Dawbarn had designed several pre-war airport terminal buildings in modernist style.

The phasing of construction meant that the scenery block was built first and then the canteen before work started on the central doughnut office and studio building. Television production could then start while work continued on more studios on a spur built from the main block, expanding down the tail of the question mark. This continuous construction always plagued the Television Centre, the sound of drilling causing constant headaches for producers and sound recordists. At its peak BBC Television Centre was a labyrinth with eight main studios.

Within all the expansion over the years, the circular eight-storied BBC Television Centre remained a fine building, unclassifiable, but with 'a strong period feel' in the words of English Heritage, scientific and futuristic in its time. A John Piper mural adorns the entrance hall; an elegant concrete cantilevered dog-leg staircase seems to hang in space. These features have been preserved in the modern Television Centre development, together with the re-gilded statue of Helios, set on a slender tapered column in the inner courtyard. The fountain below, which during BBC ownership was shut down because it was deemed too noisy during sound

Studio TC1's floor area and lighting rig have the capacity for opera, orchestras and Strictly Come Dancing *in the past.*

recording, has been revived.

To describe the building only in architectural terms is to deny the sheer cultural power of the programmes, and to ignore the BBC itself as an institution. For many, the notion that *Doctor Who* or *Blue Peter* was created here has built a mythology which the BBC was happy to encourage.

Studio 1, for example, designated TC1 in BBC style, opened in April 1964 and was estimated at the time to be the largest single studio in Europe. Most of the BBC's productions of Shakespeare were made here, and much opera, *Play of the Month*, *I Claudius*, *The Two Ronnies*, the coverage of General Elections and frequently *Blue Peter*. Later its capacity came into play for *Strictly Come Dancing*. TC1 is one of the three studios which were retained and refitted for BBC Studioworks. It is now equipped for shooting High Definition and is fitted for later Ultra High Definition formats.

RIGHT *This cantilevered staircase seems to hang in space in its glass tower to the south.*

OPPOSITE ABOVE *TC1 control room desk and monitors.*

OPPOSITE BELOW *Part of the vast lighting, cable and plug store.*

THE FOURTH ESTATE 151

BBC BROADCASTING HOUSE

Broadcast radio in Britain went from being the great novelty of 1922 to a national institution in less than a generation. By the time Broadcasting House opened at Portland Place in 1932, the BBC was already becoming established as a cornerstone of British life: worthy and responsible. While BBC announcers may have worn dinner jackets on air, there was nothing quaint about the technology or the architecture of Broadcasting House. It looked like nothing on earth and was packed with state-of-the art systems.

After one of the biggest operational and organizational upheavals in the BBC's history, a massively redeveloped Broadcasting House was opened in 2012, and it was claimed to be the most advanced broadcast and production centre anywhere. It houses nearly all BBC television, news and radio and on-line broadcast services. At its heart is the same Art Deco building, now joined on its eastern side by further structures, modestly described as the 'extension'. It still resembles an ocean liner steaming towards Regents Street: bow-shaped, with masts on the roof and circular ports on the upper level. The comparison was irresistible.

Architect George Val Myer had been set the task of exploiting an awkwardly shaped three-sided plot of land alongside All Souls Church at Portland Place. His main idea was a central tower housing the studios, insulated from the noise of the streets and excluding daylight. The tower was completely surrounded by outer layers of offices with windows. As well as having a tricky ground plan, Broadcasting House could not be made symmetrical in elevation, although a parapet

The London control room is the digital hub for national radio, and the receiving centre for outside broadcasts.

THE FOURTH ESTATE 153

154 UNSEEN LONDON

wall above the fifth floor disguised this to some extent and it avoided looking misshapen when viewed from Regent Street. One of the most extraordinary features was the way that so many different rooms were disposed about its eight storeys and three basement levels. It is impossible to find an accurate tally of how many rooms were designed into the original Broadcasting House. The architect spoke of endless flexibility for sub-division of spaces. There were certainly originally twenty-two fixed studios, sandwiched between music libraries, a restaurant, a concert hall, lounges and rehearsal spaces. Broadcasting House sometimes resembled a small town and was always a maze. It had six lifts, waiting rooms, green rooms, a telephone exchange and a post office. The cleanly styled interior, particularly in the studios – which incorporated the latest soundproofing materials – won praise. The interior had mostly been schemed by young designers Raymond McGrath, Serge Chermayeff and Wells Coates, and the building was equipped with modern minimalist furniture, clocks and custom-designed signage. On opening, there was a level of criticism from the architectural pundits, but the only major problem was that the BBC quickly grew too large for the building. After seven years of gleaming whitely in its grimy London surroundings, Broadcasting House was camouflaged with dark green paint during the Second World War, when it gained scars and served steadily.

Sixty years later, Broadcasting House – despite post-war enlargement to the north end, upgrades, repairs and endless adaptations of rooms – was overcrowded and worn out. Many of the fine features of the interior were battered or covered; the hidden cable runs had become a tangled serpent's nest; and there was a crack in the structure, and poor environmental control for most of the building. The Stronghold, an armoured concrete structure, had been erected alongside in 1942 after damage was sustained by Broadcasting House during the Blitz. It housed four new studios, and generated the myth that Broadcasting House possessed a secret platform on the Bakerloo line of the Tube, quite untrue, but the rumble of Underground trains could certainly be heard in the building. London Underground continued to plague Broadcasting House

OPPOSITE ABOVE *Once known as the Concert Hall, the BBC Radio Theatre retains bas-reliefs on the side panels and the original clock from 1932 alongside video and audio projection capabilities and satellite links for television broadcasts.*
OPPOSITE BELOW *In the sound effects drama studio, old telephones, various doors and a range of household hardware remain as traditional instruments in the digital age.*
ABOVE *The* Woman's Hour *studio, with fabric-covered tables for quietness and perforated timber panels to tune the acoustics.*

when the deeper-tunnelled Victoria line was opened underneath in 1969, and it was possible to hear these trains during studio broadcasts. That was not to be set right until Broadcasting House was completely rebuilt.

Meanwhile, Eric Gill's statues, once controversial, settled into the street scene. Over the main entrance stand Prospero and Ariel. This sculpture needed to be trimmed by the artist when found to be too tall to fit the niche, and it carries a secret sketch of a girl on the back. On the Portland Place side is *Ariel Hearing Celestial Music*. Inside, behind the reception desk, stands *The Sower*.

It took a decade from 1992 to re-equip the old building and to build the two-phase extension: first the construction of a further building to the east, and then a curving wing to join old and new. The original slate roof was replaced by a glazed double-skinned system and the interior was largely stripped and rebuilt, especially the studios, and yet it is surprising how much of the first Broadcasting House remains. The concert hall, now the BBC Radio Theatre, now incorporates the highest audio-visual capabilities; the lifts, with limestone portals from Derbyshire stone, remain; the Council Chamber on the third floor was taken out and meticulously reconstructed; the staircases were restored, and the well-used steps left unmolested.

ANGELS COSTUMES

The sign outside a modern warehouse in Hendon bears the charming legend Angels Costumes and the date 1840. Within lies the capability to accurately dress an entire school of Roman gladiators, a Tudor queen and her courtiers or a crowd scene from Jack the Ripper's London. It is 'an unparalleled dressing up box', according to the company's own history, modestly describing the mechanism whereby more than a million costumes and accessories are handled on 8 miles of hanging rails and racks.

Human resources deployed here include costumiers, dressmakers and tailors. There is expertise in bonnet making, in 'breaking down' – the art of distressing and ageing fabrics – and a research library. An armoury holds Norsemen's shields and gladiators' breastplates, which are found alongside chainmail – highly realistic but now made of wearable lightweight plastic rings. The alterations department handles reinvention and preservation – 'If you cut something in this building, you kill it,' says chairman Tim Angel – and pieces are frequently reworked, but never irreversibly. Military uniforms require special expertise with knowledge of medal ribbons, insignia and regimental history. Angels says it can outfit a large number of actors in uniforms of virtually any branch of army, navy or air force from any country. Police forces and fire departments are also covered. The furs room is kept at a low temperature to deter moths, industrial scale smoke fumigation is applied monthly and the air constantly replenished across the whole building.

An immigrant tailor from Frankfurt, Daniel Angel first sold second-hand clothes from a barrow close to Covent Garden in the 1820s. His eldest boy worked from a shop established in 1840, this being Morris Angel & Son, and as the business took on

The warehouse holds more than a million pieces, racked by period, gender, style and colour.

THE FOURTH ESTATE 157

ABOVE *Military uniforms require expertise for accuracy, for insignia, rank and period.*
OPPOSITE ABOVE *The jewellery room.* OPPOSITE BELOW *Racked dresses of the 1980s.*

tailoring it also developed the idea of renting clothing to actors, who in that age had to provide their own costumes. A move to Shaftesbury Avenue followed, close to the centre of London's fast developing theatreland. The clothier and theatrical costumier soon added the production of military uniforms. Opera houses became customers. Morris Angel & Son supplied costumes for a moving picture as early as 1913. Television and advertising eventually followed film. Daniel Angel's seventh-generation descendants own and run the company today.

As many as twenty costumier companies once operated in London but that number has declined to a handful of specialists. Angels became the major player after acquired its main competitor Bermans & Nathans in 1992, and claims to be the largest costume house in the world.

There is no computerized cataloguing system in operation at the Angels warehouse which relies on the knowledge of its costumiers to navigate the stock. Costumes are grouped by style, colour and historical period, from Roman times to the 1990s, with special sections for ecclesiastical, legal and nightwear.

Angels has supplied costumes for thirty-six films that have won the Academy Award for best costume design. In 2016 the British Academy of Film and Television awarded Angels a BAFTA for Outstanding British Contribution to Cinema.

Costuming for film accounts for just over 33 per cent of the business, and theatre 20 per cent. A high proportion of the remainder is fancy dress hire, run from the original Shaftesbury Avenue premises which continue as the fancy dress department of Angels.

DAILY EXPRESS BUILDING, FLEET STREET

The Daily Express Building at 120 Fleet Street caused a sensation at its opening in 1932 with its curvaceous black glass skin and its stunning Art Deco lobby. Fleet Street up until then had been lined with bland buildings resembling banks, and the Express building stood out marvellously. Sir Owen Williams was praised as the creator of the design, but the credit for the building should be shared. The design of the lobby was handled by another architect, Robert Atkinson, who had created several super-cinemas with lavish interiors, and here he emulated the style of the most extravagant skyscraper entrances of the time. A starburst ceiling is moulded into a lantern. Serpent handrails flank the approach to an oval stairwell. Rosewood veneers, smooth marbles and reflective metallic surfaces abound, bracketed by two relief murals.

Even some of the most high-minded architectural critics of the time liked the building, although the Modernist principle that interiors should be integral to the building does not seem to have been applied in this case. The building was not for architectural purists, although the public loved it. Insiders admired the structure by Sir Owen Williams, who was a civil engineer for years before he became an architect, and a specialist in concrete structures, spending much of the 1920s working as structural engineer on a succession of bridges.

His expertise solved a problem for Beaverbrook Associated Newspapers, who had started to extend its Fleet Street headquarters with a steel-framed design, but found the grid

RIGHT *Snake design handrails flanking the approach to the staircase were recreated for the restoration of the building.*

OVERLEAF *A relief sculpture entitled* Britain *by Eric Aumonier looks down on the marble, rosewood and metallic surfaces in the entrance lobby with Fleet Street to the left.*

THE FOURTH ESTATE 161

would be too intrusive, robbing them of space. Space was critical in the basement, where three huge presses were to be positioned. The engineering solution was to build a reinforced concrete eight-legged table straddling the basement with a mezzanine floor as the top. Over this, a series of single-span frames were stacked upwards. On the outside of the ribbed floors were mounted panels of black Vitrolite glass supplied by Pilkington, with clear window glazing hung between. The joints were covered by sills made of a newly developed alloy called Birmabright, which shined in sunlight. At night, the Express Building exuded activity, with the windows, divided by the alternate opaque layers, always brightly lit up. The black glass building set a house style for Express Newspapers, and very similar premises for the company followed in Glasgow and Manchester (which improved on 120 Fleet Street by surrounding the street-level print hall with glass).

A mystery remains over exactly who was inspired to apply the black glass to the structure. Some architectural historians have said it may not have been the bridge builder Sir Owen Williams, who disliked adornment and had said 'architects do little more than decorate what the structural engineer has achieved'. His contemporaneous factory building for Boots at Nottingham has strictly functional glass. Robert Atkinson does not seem to have contributed to the exterior. The original architects for the steel frame design, Ellis & Clarke, had been retained, and may have contributed the Vitrolite panels, but their first submission had used Portland stone cladding.

OPPOSITE *Beaverbrook Associated Newspapers included the* Sunday Express; *the decorations below the deco sign are maple leaves, denoting the Canadian ancestry of the ownership.*
LEFT *The oval-plan stairwell, in lavish cinema style, has been extended during the restoration.*

Another possibility is that the Lord Beaverbrook himself exerted a strong personal influence on the finish, as the North American-born press baron craved a building of self-confident modernity to set it ahead of its staid rivals. In 1932 the *Daily Express* was just getting into its stride, soon to break the 4 million daily sales barrier to become the world's best-selling newspaper. If anything, 120 Fleet Street is a monument to what was the greatest popular newspaper of its time.

What can be seen today in the building, which is occupied by Goldman Sachs, is much more than a restoration. Between 1998 and 2000 Hurley Robertson & Associates re-engineered and improved on what had existed in the later days of newspaper ownership. An extension called Aitken House had grown flush on the east side, which even when clad in Vitrolite was a clumsy addition. Aitken House was demolished without a murmur, and a smoothly curved pavilion added on the east side to make the building symmetrical for the first time. The building had stood empty for years after the newspaper left in 1989, and much had been lost in the way of fixtures, which had to be recreated, including the metal snake handrails.

The fabulous entrance lobby lives on, cleaned and upgraded as a tribute to Atkinson, much of whose other work has been demolished with the demise of cinemas. The plaster ceiling has been strengthened and the original wave patterned floor design recreated in terrazzo ceramics. Two stylized patriotic relief sculptures by Eric Aumonier depicting Britain and Empire continue to look down.

ROYAL LONDON

HAMPTON COURT PALACE

Hampton Court Palace has been described by one of its curators as the greatest semi-detached house in the world, and the official guide says it is best understood as a Tudor palace joined on the side by a much later Baroque house. Hampton Court was first of all a modest moated manor house developed by Cardinal Wolsey, which in 1528 came into the possession of King Henry VIII and extravagantly expanded. The Palace was extensively reworked to the design of architect Christopher Wren in English Baroque style for William III and Mary II when more than half the Tudor buildings at Hampton Court were demolished.

It served as a functional royal palace for just over 200 years, its last royal occupant being George II who stayed there in 1737. Hampton Court's only residents from mid-eighteenth century were those who had given service to the Crown or country and granted apartments around the former royal residences by the grace and favour of the monarch. The Palace and its extensive parks and gardens was first opened to the world by Queen Victoria in 1838. Its conservation and restoration has continued ever since. Most of the palace buildings are open to the public today and other parts are used as offices housing the headquarters of the Historic Royal Palaces organization.

While the drama of the Tudor period seizes the imagination of most visitors – all of King Henry's six wives stayed here at one time or other – there are other layers of history to be seen. The building with the longest continuity of use is the

PREVIOUS PAGES *Looking south across Clock Court, the palace's signature Tudor chimneys number 241, many of them recreated in the nineteenth century.*
RIGHT *The Chapel Royal is filled with imagery – secular and holy – to the glory of both God and King.*

ROYAL LONDON 169

170 UNSEEN LONDON

ABOVE *Anne Boleyn Tower, the black cross-frame may date back to the sixteenth century. The movement driving the clock is believed to be the fifth installed, this one made in 1879.*

OPPOSITE *Behind the face of the much overhauled and reworked astronomical clock.*

Chapel Royal, which spans the entire history of Hampton Court Palace. It was planned and started by Cardinal Wolsey, decorated on the orders of the King, and rebuilt to the design of Wren in 1710. Oak panelling, pews and altar all belong to this later period. The Grinling Gibbons altar screen replaced windows smashed by Parliamentarians in the 1640s. Yet the most spectacular feature remains the decorated Tudor pendant-vaulted ceiling completed in 1536, with sixty gilded angels descending from a starred blue sky. It appears to be stone, but is in fact a rare structure of wood and plaster, prefabricated by a team of carvers and carpenters based miles off-site and shipped on the Thames to Hampton Court for assembly. The only clue to this use of material can be found in the roof space, where the lattice of wooden beams and pegs upholding the angels and bosses can be seen.

Henry VIII's only son, Edward VI, was baptised in the Chapel. Under the altar is buried the heart of his mother Jane Seymour, the king's third wife. The room where she died and where Edward was born, Apartment 33, is close by, austere, unfurnished and intact.

An historical oddity is that Oliver Cromwell's daughter Mary was married to Lord Falconbridge in the Chapel Royal on in 1657. Some historians make a strong case for attributing the very survival of the Palace to Cromwell. Although the

Puritans seized Hampton Court Palace in the Civil War, and its soldiers inflicted some damage, Cromwell himself used to enjoy spending weekends here during his time as Lord Protector. Plans were announced to strip the palace and dispose of the buildings and land but these never quite developed and the palace survived battered but intact for the Restoration of 1660.

Over the Anne Boleyn gateway facing the inner courtyard is a famous astronomical clock with a geocentric dial of three copper discs. Its design, which places the earth at the centre of the universe, was not informed by the discoveries of Copernicus and Galileo, and is a flawed but impressively complex instrument.

It shows the day and month and the position of the sun in the zodiac and the time of day is indicated against the fixed ring on the stone bezel. An arrow on the smallest central dial rotates once each lunar month, and when read against the centre dial tells when the moon crosses the meridian each day, a facility which enables the tide to be read. It shows the time of high water on the Thames, useful for members of court who travelled to Hampton Court by barge.

BELOW *The astronomical clock has a globe representing the Earth at its centre, with the sun positioned outboard on the long pointer.*
OPPOSITE ABOVE *The blue pendant-vaulted ceiling has been restored and is exactly what Henry VIII would have seen.*
OPPOSITE BELOW *Above the ceiling of the Chapel Royal are the pegs and beams from which its decorative features are suspended.*

ROYAL LONDON 173

174 UNSEEN LONDON

TOWER OF LONDON

It is hard to argue the case for a single most compelling event in the history of the Tower of London. As the place of imprisonment and execution of Queens Ann Boleyn and Jane Howard, and later of Lady Jane Grey, history here is transmuted to legend. There is the prevailing mystery of the Princes in the Tower, and the story of Elizabeth's entry through Traitor's Gate for incarceration, her future poised on a knife's edge. Of the twenty-one castle towers that once made up the whole complex, the most conspicuous is the White Tower central keep, while the Bloody Tower, where the young King Edward V and his brother the Duke of York were likely murdered, is most notorious. Many of the fine details of history are found elsewhere in the Tower of London, and remain visible, although not always open to visitors.

The Queen's House, the timber-framed building constructed first for Anne Boleyn to the south of Tower Green, contains a curious alabaster and marble memorial which effectively commemorates the failure of the Gunpowder Plot of 1605. Guy Fawkes and other conspirators were seized and brought into the hall of the house for interrogation under the supervision of the Lieutenant of the Tower, Sir William Waad. The monument records the names of the conspirators in the centre, surrounded by the names of the Privy Councillors who conducted the questioning. Curators at the Tower believe that Waad commissioned the monument the year after the executions of the plotters when the council room was created. The intention was to record the success of the investigation for purposes of prestige and as a marker to intimidate of any

Although securely held in place by modern metal beams, the Byward Tower portcullis, the oldest in Britain, remains capable of operation.

A possible sign of sorcery, the astrological sphere carved by Hew Draper.

future offenders interviewed in this room. Historians believe that the first questioning of Guy Fawkes here was probably a relatively civilized affair, as befitted a gentleman. The third degree was applied elsewhere shortly afterwards, most likely at ground level of the White Tower, precise location unknown, for there is no certain knowledge of where the torture chamber was, or if even such a dedicated room existed.

Nearby in the base of the Bell Tower is the place were Sir Thomas More, the learned Lord Chancellor who clashed with Henry VIII, was imprisoned, a bare vaulted space with a stone floor and a garderobe in the corner. It has a reputation with Tower staff today of always being a cold environment, although for More it would have been quite comfortably furnished and a servant was allowed, as the King hoped for a change of heart from Sir Thomas. It was his home for some months before he was taken to Tower Hill and beheaded in 1535.

Byward Tower, built by Henry III and completed in 1272, is the main entrance to the Tower of London and incorporates several hidden features. One is the original portcullis, which after being raised and lowered routinely until the early years of last century, is today is securely fixed out of sight in the raised position. The 700-year-old windlass lifting gear and gate are of all-wooden construction and the device is still capable of functioning, having been lowered for test purposes as recently as 2001. In a room, adjacent to the raised portcullis is a wall painting uncovered in 1953, and now carefully preserved. It

LEFT *A Tudor rose and chimney breast olbiterate the central figure of Christ in Byward Tower.*
BELOW *Sir Thomas More's final months were spent here.*

depicts St John the Baptist and the Virgin Mary, St John the Evangelist (Baptist) and the archangel St Michael who is holding scales weighing Christ's soul in judgement. The central figure of the crucifixion of Christ has been obliterated by a Tudor rose and a fireplace which was later emplaced in the wall. Expensive pigments such as azurite, vermillion and gold leaf were used in the painting which is dated to the 1390s and was clearly of some importance. The reason for its mutilation is not recorded, nor is its precise significance properly understood, although a curator has connected it to the presence of to the Royal Mint in the Tower, posting an admonitory warning to operatives that all behaviour is subject to judgement.

At odds with Christian imagery are some elaborate designs carved by into the wall of the upper chamber of Salt Tower and dated 1561. A complex astrological wheel with zodiacal symbols and a detailed calendar is signed by Hew Draper, a Bristol innkeeper imprisoned on suspicion of sorcery. He admitted to have been interested in magic, but said he had destroyed his magic books. Whatever effect the making of the carvings had on his sentencing in not recorded. Draper's fate is unknown.

Council room of the Queen's House, with a tablet naming conspirators of the Gunpowder Plot and the men who convicted them, with a bust alongside of the Stuart King James I, all dating from about 1608.

ROYAL LONDON 179

180 UNSEEN LONDON

KING HENRY VIII'S WINE CELLAR

In 1938 Queen Mary, widow of King George V, asked that the last remaining part of the ancient Whitehall Palace be kept from destruction; in fairy tale style courtiers accepted the challenge and granted the wish, overcoming great difficulties in the process. King Henry VIII's wine cellar, as it has come to be known, is brick-ceilinged with supporting ribs, carried by four octagonal stone pillars dividing the room into bays. It measures 70 × 30 ft (21 × 9 m), built in 1516 by Cardinal Wolsey and seized by Henry VIII.

By the end of the nineteenth century the houses on the site had been requisitioned by the civil service, which had developed a voracious appetite for office space. They were soon to be overwhelmed by a huge development blandly known as 'New Government Buildings': a ten-storey colossus destined for a position on Horse Guards Avenue and Whitehall. Standing in the pathway of progress was the wine cellar, which was being used as a canteen for the Ministry of Transport.

Queen Mary's request for preservation had come just before demolition work on the Georgian houses started. In December 1946 an extraordinary procedure was started to move the wine cellar to a new position. Dismantling had been studied, but the type of brick used in the cellar precluded that, and the solution was to excavate and build a steel carrying frame to the side of the wine cellar, fitted with rails. The complete cellar was then undermined, encased in concrete and mounted on a platform which enabled it to be moved sideways onto the carrying frame.

When the original site level had been lowered and a new concrete foundation laid, the wine cellar was lowered on screwjacks built into the frame and edged sideways back on a shorter journey, just 9 ft (2.75 m) less far to the east and nearly 19 ft (5.75 m) deeper than before.

The relocated wine cellar, now under the Ministry of Defence.

THE BANQUETING HOUSE

Banqueting House was a stunning sight when unveiled in 1622, the first building anywhere in England in Palladian style, and an elegant addition to the disordered collection of medieval houses that made up the monarch's Whitehall Palace. It was the forerunner of what became much later a kind of neo-classical corporate style for official buildings, but that trend did not start until the following century. In the intervening years England was torn by a Civil War and Whitehall Palace was almost completely destroyed by fire. Banqueting House survived as Inigo Jones' masterpiece and an inspiration for future architects.

Inigo Jones was appointed Surveyor of the King's Works for James I. He had visited Italy, studying and recording the architecture of the Italian Renaissance, notably by Andrea Palladio, who himself had been inspired by the buildings of ancient Rome.

The hall inside Banqueting House occupies most of the space: a huge room made pleasing by its classical symmetry and proportions, being twice as long as it is tall and wide. It is lined on each side with eight Ionic half-columns supporting a balustraded balcony and further pilaster columns above reach to the ceiling. The purpose of the hall was to provide a space for the performance of masques, the elaborate theatrical and musical entertainments in vogue during the early seventeenth century, for official receptions and audiences of visiting diplomats.

King James was succeeded in 1625 by his son Charles I and during his reign came the commissioning of its most spectacular decoration, the ceiling paintings by the Flemish artist Peter Paul Rubens. The nine paintings are classical

The Banqueting House from the balcony.

ROYAL LONDON 183

184 UNSEEN LONDON

OPPOSITE ABOVE *The much-restored Peter Paul Reuben's paintings decorating the Banqueting House ceiling.*

OPPOSITE BELOW *The pegs securing Reuben's paintings to the ceiling in the roof void.*

allegories and the three large central pictures – showing the Peaceful Reign of James I, the Apotheosis of James I and the Union of the Crowns – assert political points and carry strong elements of propaganda. Here is the great achievement of King James I: the joining of the crowns of England and Scotland, the depiction that the king was answerable only to God and the idea that the wisdom of the monarch brings peace and prosperity.

In 1636 the paintings were shipped from Antwerp to London. It was found that due a misunderstanding over units of measure between painter and architect, at least four of the pictures did not fit the ceiling spaces. Canvases were extended, repainted, remounted and pegged to the ceiling. Given the precious nature of the images, the pictures have since been subject to robust treatment, undergoing at least twelve restorations, and five removals, including remounting the canvases on plywood in 1906, and a sojourn in a barn in Hertfordshire for safety during the Second World War. At this time the nine panels were cut into twenty pieces to facilitate removal and replacement.

A strange feature of the Banqueting House is its comparatively dowdy entrance, attached in an annexe on the northern end, set back from the façade and enclosed by railings. Little attention is paid to this, which is the place of execution of Charles I. The momentous event is modestly commemorated by a black lead bust of the King set in a niche above the doorway with the legend: 'His Majesty King Charles I passed through this hall and out of a window nearly over this tablet to the scaffold in Whitehall where he was beheaded on 30th January 1649.' On that morning, King Charles was escorted across St James's Park, then over Whitehall by an archway known as Holbein Gate, and into Banqueting House. A scaffold had been assembled in front. The king crossed the hall under the Rubens ceiling and then passed through an opened-out window space to step onto the scaffold. This window was most likely set in the entrance annexe, which was reworked in 1798. Extensive study has been unable to locate the precise point of exit and execution, except that researchers calculate that anyone walking along the pavement directly in front of Banqueting House today must pass under the spot where the king was beheaded.

Forty years after the execution came the last great ceremonial occasion held in Banqueting Hall. The throne was offered to William of Orange and Mary II, after a reading of the Declaration of Rights. Banqueting House survived the fire of 1698 after which Whitehall Palace ceased to exist. It was refitted as Chapel Royal and often home of the Maundy Money ceremony. It continued as a chapel until 1890 and afterwards as a military museum until reopened as an historic building in 1964.

33 PORTLAND PLACE

One of the most striking locations of any feature film set in London is a Victorian billiard room hidden in the neo-classical Adam townhouse at 33 Portland Place. It played a leading role in the 2010 film *The King's Speech*, which tells how King George VI, suffering from a severe stammer, is aided by speech therapist Lionel Logue. The room is shown in the film as Logue's consulting space. Although it seems a product of a set designer's craft and imagination, the room exists just as it appears in the film.

The sixth leaseholder of the elegant 1789-built house at 33 Portland Place, was James Blyth, industrialist and agriculturist, who took over the property in 1893. He commissioned a series of modern changes including a lifting dividing wall between the music and dining rooms, powered by water pumped by the London Hydraulic Power Company, and an enormous billiard room inside the central light well at ground floor level where the main building meets a mews house behind. These early-twentieth-century additions remain alongside the original rooms with fine plasterwork and fireplaces and an impressive main staircase. From the late-1950s the building was the embassy of Sierra Leone. In 1998, it came into the possession of controversial entrepreneur Edward Davenport, and was the scene of photoshoots, location shooting for several films and a venue for erotically themed parties. Commercial activities at the site were eventually debarred by Westminster Council.

The latest owner is businessman and publisher David Sullivan, co-chairman of West Ham United football club, who acquired 33 Portland Place in 2015 with plans to restore the building as a modernized luxury residence.

The famous billiard room may also be glimpsed in fashion shoots and music videos.

ROYAL LONDON 187

BODY AND SOUL

NEW WEST END SYNAGOGUE

It is impossible to attribute the New West End Synagogue in Bayswater to a single architectural style, although it unmistakably belongs to the late Victorian period, when neo-gothicism boomed and red brick and terracotta were being liberally applied to both sacred and secular buildings. There is also a suggestion of Moorish Revivalism, and other influences on the building have been described as Saracenic, Byzantine, Assyrian, Neo-Grecian, Orientalist and Romanesque. Most commentators and architectural writers quickly settle on the word 'eclectic'.

The consecration of the synagogue in 1879 came at a time of growing self-confidence for the Jewish community in London. Judaism in early-nineteenth-century Britain had undergone a cautious emancipation into social acceptability. Scholars have described how an English form of Judaism had first evolved. In the words of a past president of the New West End, 'the United Synagogue was the Anglican Church, Jewish division', with some Jewish ministers of the time wearing clerical collars and preferring the title 'Reverend'. Synagogues built early in the century had been much in the Christian style. In case of the New West End Synagogue, however, the interior in particular was created as lavishly and exotically Jewish.

A key event had been the appointment of the first Jewish Member of Parliament, Baron Lionel de Rothschild, in 1858, and he became a main patron of the new synagogue, making a grant towards the purchase of the site in Bayswater, an area where many prosperous and prominent members of the community had settled. Another force behind the building was banker Samuel

PREVIOUS PAGES *New West End Synagogue, Bayswater, dating from 1879.*
LEFT *The Ark flanked by menorahs, with the rose window behind and the* almemar *(pulpit) in the foreground.*

ABOVE *Torah scrolls.*

OPPOSITE *Facing the Ark, with scrolls behind and cupola and minarets above.*

Montagu, later Lord Montagu. Leaders selected the architect George Audsley, who had already designed a synagogue in Liverpool, which had pioneered an emphatically Jewish cultural style. Rothschild laid the New West End Synagogue foundation stone in 1877.

The Ark is made of marble and alabaster, topped with a canopy comprising a gilded cupola and minarets. High behind in the west wall is a rose window, one of two in the synagogue, which are the clearest examples of straightforward gothicism in the design. The equally lavish pulpit is placed centrally.

Some forty stained glass side windows are by Nathaniel Westlake, and these date from 1905. However, for the most part, the synagogue remains in its original condition, with the exception of a few later additions in the form of alabaster wall linings and smoothly executed marble coverings for the iron columns. As in almost every religious building in Britain, there is a memorial for members of congregation who died in two World Wars.

Several detailed features are almost rendered unseen by the complexity and sheer opulence of the decoration. The *bimah* (the central platform from where the reading is done) is supported by forty-nine columns, each of which is decorated differently. High in the prayer hall the spandrels (the curved areas above the arches) are filled with marble panels, again each of them with different design of embellishment.

Patron Samuel Montagu was a man of considerable girth. From the start his seat in the front row to the left of the Ark had the centre armrest removed, and it remains that way today.

Just 130 years after the foundation stone was laid, the synagogue received Grade I listing. In 2007, English Heritage raved in its recommendation for listing, citing mostly the quality and diversity of the interior decoration, and its historical significance. It even noted the brass fittings of the lighting system. Electrical lighting was introduced to the synagogue before the nineteenth century was done, and it is rated as one of the most complete late Victorian examples remaining.

LAMBETH PALACE

Lambeth Palace, the Archbishop of Canterbury's official residence, is a spiritual place that bears the marks of 800 years of turbulent history.

The palace's history began in 1190, when the Archbishop of Canterbury, Baldwin of Forde, traded the Isle of Grain in Kent for 24 acres of Lambeth territory from the bishop and monks at Rochester, but it was Stephen Langton, appointed in 1207, who was the first Archbishop to live in Lambeth Palace, bringing the clergy closer to Westminster and the Royal Court.

The collection of buildings are mainly from the fifteenth and sixteenth centuries, but the chapel and crypt are thirteenth century, finished in 1220. The vaulted undercroft originally stood alone with an external stair at its western end, but it is now connected to the palace. It was initially used for storing beer and wine, with its floor level likely raised to counter flooding from the Thames. Indeed, the high position of the window seats suggests floodwaters rose to several feet above the current floor. During the Second World War, Archbishop Temple used the crypt as an air raid shelter, with local people invited to take sanctuary. It was only in 1987, in the time of Archbishop Runcie, that the crypt became a permanent chapel. The fresco of Christ in Glory hanging on the crypt chapel's wall was given by Pope Paul VI to Archbishop Ramsey in 1966 to mark what was the first official meeting between Canterbury and the Papacy since the Reformation.

The fourteenth-century Guard Room, so-called because the Archbishop's office once allowed him to deploy soldiers, to witness gatherings of combat troops and to store military hardware. It was in this room that Sir Thomas More refused to swear the Oath of Supremacy. Paintings depict the Archbishops of Canterbury between 1602 and 1783.

Also dating back to the thirteenth century is Lollard's Tower, which bears one of most poignant features of Lambeth Palace. An empty niche on the riverside wall once held a statue of St Thomas of Canterbury, which used to be saluted by Thames watermen as they passed, until Henry VIII ordered it to be removed. Lollard's Tower once housed a prison. Seven iron rings remain anchored to the wall, and prisoners' graffiti can be found there. The tower was largely gutted in the Blitz, as were other buildings at Lambeth Palace.

In the seventeenth century, Archbishop Laud invested in modernization of the private chapel of the Archbishop by funding a programme to include a new pulpit and altar table, a richly carved screen and pews. Sadly, the stained glass windows he commissioned ran afoul of the Puritans, who smashed every one. Laud's High Church policy reflected in sermons, likely from that new pulpit, did not impress the Parliamentarians; like his king, he made the trip to the block. A Second World War incendiary device put paid to the glass again, and the ceiling was destroyed at the same time. Scorch marks can still be detected on the marble floor.

The south front of Lambeth Palace, with crenellated towers guarding the main entrance, is forbidding, even stark in style, but the influence of Westminster and St Alban's abbeys can be seen in the intricate ornamental work.

The Great Hall houses much of Lambeth Palace's library. It is red brick with stone quoins, entablatures, battlements, capping and window tracery, and has been reconstructed and revamped several times. In Tudor times, Archbishop Warham received the theologian Erasmus and painter Holbein here, and Henry VIII enjoyed Cranmer's largesse here. A century later, with the Crown in disgrace, a certain Parliamentarian Colonel Scott ordered the hall's demolition, putting valuable building materials up for public auction, and using what remained for billeting Roundheads. Not until 1660 would Archbishop Juxon, who had seen Charles I on his way to the block, restore the hall, insisting on a replication of its original

medieval style. Despite Juxon's enthusiasm and efforts, the hall went all but unused for decades until the nineteenth century. Neglected and grubby, it became part of Edward Blore's restoration programme, the architect giving it a new lease of life as the library. The Great Hall's hammerbeam roof was another casualty of the Blitz. In the post-war restoration programme, Archbishop Juxon's design was copied.

Morton's Tower is a red brick castellated Tudor gatehouse, which serves as the entrance to the modern palace. It was built close to 1490 by Cardinal John Morton, who lived in the tower briefly. On the ground floor of the south battlement tower is another small cell used for sixteenth-century incarceration. When a young Thomas More joined the Lambeth Palace staff as a page aged twelve, he is believed to have lived in this tower. As a man, Sir Thomas More was summoned to the Guard Room at Lambeth by Thomas Cromwell to swear the Oath of Supremacy declaring Henry VIII head of the Church of England, which he declined, leading to his execution.

OPPOSITE *The Blue Dining Room.*

BELOW *Another part of Lambeth Palace destroyed by Second World War bombing was the State Drawing Room, rebuilt in plain style during the 1950s. It would not be until 1998, when Archbishop Carey's wife refurbished the room, that it took on its old splendour, seen in the ceiling's moulded plaster work designed in the style of 1828 plans. Guarding the fireplace is a portrait of King Charles I in garter robes, possibly the work of Van Dyke. A second portrait is believed to depict Henry Frederick, Prince of Wales, who died from typhoid fever in 1612.*

ST BRIDE'S CHURCH, FLEET STREET

St Bride's Church is the embodiment of London history. It is the site of at least seven buildings of worship, the first Roman, then Saxon, followed by Norman churches. The largest and last of these, built in the fourteenth century, was destroyed by the Great Fire in 1666. Replaced triumphantly by a Wren masterpiece, this church was wrecked in the Blitz on the night of 29 December 1940.

St Bride's timeline is long and its layers are deep, but they were only revealed in detail when work began to rebuild the ruined Wren church. This led to the first proper archaeological excavation of any City of London church. Under St Bride's, a fragment of Roman pavement and wall were found, as well as the nave of the Saxon church. At the same time, the crypts were found to contain more than 200 skeletons, some of them victims of the Great Plague of 1665, others from the cholera epidemic of 1854, following which the crypts were sealed by Act of Parliament. Another separate set of remains, numbering thousands of bones, was uncovered and this was identified as the site of a medieval charnel house. The bones and the metal coffins from the crypt are still being analysed today.

St Bride's position as the journalists' and printers' church dates back to 1500, just after the death of William Caxton, inventor of the moveable type printing press. An apprentice of his, Wynkyn de Worde, acquired his master's press, and set up shop in the churchyard of St Bride's. It was a good location to supply printed pages to nearby offices of the legal profession and to publishers of plays and books. Newspapers came two hundred years after that. St Brides, just a few paces from Fleet Street, became the parish church of the local industry: printing and journalism.

Restoration of the ruined St Bride's started in 1954. The octagonal wedding cake steeple had survived, and the walls still stood but the rest of the church was gutted, and the bells had melted. Only the medieval gospel lectern, which had survived the Great Fire of 1666, was rescued by parishioners in 1940. Restoration by Wren expert Godfrey Allen was faithful to the original but not slavish. The galleries over the aisles were not replaced. The scientifically minded Wren favoured plain glass and this style was followed, only one significant new window being stained glass.

As St Bride's was completed and rededicated in December 1957, Fleet Street was approaching its high-water mark. Newspaper circulation was booming. The street and the area around were a densely packed concentration of print journalism. National newspapers with roaring presses in the basements stood alongside humming wire services and outposts of provincial newspapers and foreign publications. In smaller offices lurked picture bureaux and features agencies, and obscure trade publications were seemingly packed into broom cupboards. The support infrastructure, in the form of drinking establishments and feeding stations, was highly active, witness to long lunches and scoops celebrated. Close to the middle of it all, St Bride's fitted rather well into the teeming scene, a spiritual home of a sometimes unspiritual profession.

But by the end of the 1970s, new print technology caused a convulsion, which forced the media occupants of Fleet Street

The floor of the nave is paved with black marble from Belgium and white marble from Italy. The entire interior was built during the 1954–7 restoration.

UNSEEN LONDON

and the nearby areas to disperse and decline. In Fleet Street proper, the *Daily Telegraph* and *Daily Express* had left before the end of the 1980s, and accountants and corporate lawyers started moving in. St Bride's closest journalistic neighbour, the Reuters news agency, lingered until 2005. That building is now Lutyens Restaurant. Across the street, the *Daily Express* building is now occupied by investment bank Goldman Sachs. St Bride's the journalists' church has outlived most journalism in Fleet Street, but thrives as a place of worship, and continues as spiritual home of the media through a charitable trust, memorials to reporters killed in action and a permanent exhibition in the crypt.

St Bride's is riddled with so much history across 1,500 years that it is surprising how many artefacts remain, some from Roman times. Its name is Celtic, from St Bridget of Kildare, a fifth-century Irish saint famous for her hospitality. An early American connection is visible by the font in the form of the bust of a girl, Virginia Dare, the first child born to English emigrants to North Carolina in August 1585, who were married at the church. Another is the altarpiece memorial to the Pilgrim Fathers; one of the passengers aboard the *Mayflower* was Edward Winslow, later three-times Governor of Plymouth Massachusetts, who was a former Fleet Street printer's apprentice, and would have known St Bride's well. Some elements are unseen, however, and must be imagined. These include illustrious parishioners John Milton, John Dryden and Samuel Pepys, who was baptised there, and also Benjamin Franklin, who acted as a technical consultant on the design of the lightning conductors for the spire when it was being built.

Discovery of a Roman pavement under the church in 1953 enabled archaeologists to set up a timeline for St Bride's.

ΟΝΟΜΑΤΙ ΚΥΡΙΟΥ ΩΣΑΝΝΑ ΕΝ ΤΟΙΣ ΥΨΙΣΤΟΙΣ

ST SOPHIA'S GREEK ORTHODOX CATHEDRAL

A recurring theme in this book is a conventional building, meriting barely a second glance from a passerby, containing a marvellous interior. St Sophia's Greek Orthodox Cathedral in Moscow Road, Bayswater, is a fine example.

It was consecrated in 1883, and its exterior is modestly neo-Byzantine in style. This architectural form was the subject of a revival at the time, and was being applied to new churches in different denominations, including the Catholic Westminster Cathedral. The Cathedral of St Sophia has nicely detailed yellow-and-red brickwork, and is a well-proportioned cruciform, but only the copper domed roof hints at higher design.

This is revealed in the spectacular interior, in an exotic Eastern Orthodox style, much of which is embellished with mosaics. Green, black, white and pink marble panels line the walls.

The iconostasis (the screen that separates the nave from the sanctuary) is an elaborate walnut structure embellished with twenty-two images. To fully appreciate the beauty of the church it may be necessary to have some knowledge of iconography, especially the placement of each icon. It also helps to have an understanding of significance of the holy doors in the iconostasis, but the mystery of the Orthodox Church is palpable. In the high dome is the image of Christ Pantocrator, one of the oldest images in Christianity. The mosaic floor bears the coat of arms of the Byzantine Empire: the double-headed eagle.

There had been a Greek church in London since 1677, and a stone from the very first is preserved in St Sophia's. St Sophia's foundation and its location owed much to the growing Greek colony in the years following the nineteenth-century War of Independence, and the prosperous Greek merchants trading from London.

St Sophia's was designed by John Oldrid Scott, from the famous family of architects (son of Sir George Gilbert Scott, uncle of Sir Giles Gilbert Scott) and work was started in 1877. The church was elevated to the status of a cathedral in 1922.

In 1926 the Cathedral trustees commissioned the Russian artist Boris Anrep to create a further set of mosaics, depicting the incarnation of Christ and the mystery the Eucharist. Anrep was invited to decorate further sections of the cathedral between 1932 and 1956, including full-length figures of the Major Prophets and busts of the Minor Prophets. In the west arch he depicted St Nicholas and St Christopher with Christ, both protectors of the seafarers and travellers, resonant with a congregation historically associated with shipping and trading.

For a while during in the Second World War, when the Greek government was in exile in London, St Sophia's was designated the cathedral of the Greek nation. During the Blitz, bombs destroyed buildings a few metres away across the street, and St Sophia's suffered blast damage that was not repaired until after the war.

Christ Pantocrator, the iconographic image of the Almighty surrounded by the twelve Apostles, looks down from the dome.

ABOVE *Icon stand positioned in the nave.*

ABOVE *Detail of cathedral seating.*

OVERLEAF *The iconostasis screen dividing the nave from the sanctuary, covered with groups of icons, including images of the Incarnation and the Second Coming of Christ.*

ST CHRISTOPHER'S CHAPEL

The small luminous chapel of St Christopher at Great Ormond Street Hospital for Children is charming and poignant. The pews are scaled for children and themes of childhood can be traced throughout the chapel. There is a prayer tree where messages can be placed for sick children.

St Christopher's was built in 1875 in the popular neo-Byzantine style as Great Ormond Street gained a new central building by architect Edward Middleton Barry. The chapel was dedicated to the memory of his sister-in-law Caroline, whose husband made the donation which funded its construction. All the original decoration, not just the stained glass, is attributed to leading interior specialists Clayton & Bell.

When the chapel was restored, and reopened by Princess Diana on 14 February 1994, it marked more than a revival of its alabaster, marble and glass. Following an operation that took two years to prepare and complete, the chapel was moved more than 60 ft (20 m) from where it had been built. Over time, Barry's monumental neo-gothic Victorian block presented increasing problems for the hospital, proving impossible to adapt for modern needs. There was a need to make a new clinical building on the spot. With the embedded chapel being Grade II* listed and a part of the Great Ormond Street legend, a radical solution was found. As the surrounding building was demolished, the chapel, then at first floor level, was cross-braced, underpinned by a concrete raft and enclosed in a sealed box. Lowered to the ground, it was moved by hydraulic rams on lubricated skates to its new position without harm.

The chapel is a very special place for patients, staff and families at the hospital and is therefore not open to the general public.

FREEMASONS' HALL

Freemasons' Hall, a monumental structure that overshadows Great Queen Street between Covent Garden and Holborn, is visibly laden with architectural gravitas, which may be appropriate for an organization inspired by the builders of medieval cathedrals and castles. In popular imagination, the building may also be endowed with great secret significance, representing concealed power dating back a thousand years.

But Freemasons' Hall is of recent construction, and Freemasons themselves emphasise that it is not a religious building. Freemasonry, they say, is secular and non-political, and is engaged in a multitude of charitable fundraising and volnteering activities. Free guided tours (available up to five times a day, six days a week) are one of London's lesser-known pleasures, but far from secret. Freemasons' Hall's remarkable interior only qualifies as 'unseen London' for those unwilling to look inside. Those who do may find the application of symbolism overpowering. If the Hall itself is not riddled with secrets, its decoration is at least crying out for interpretation.

Freemasons' Hall is the third masonic building on this site since 1775. It was built between 1927 and 1933, and financed by a million-pound appeal, although the final cost was more than one third greater than that. Put out to competition, the winning design was by architects Henry Ashley and Francis Winton Newman, a partnership who specialized in functional designs for industry, commerce and public buildings. It is steel-framed and clad in Portland stone, and aligned diagonally to the local street plan.

The First World War and its aftermath exerted a profound influence on Freemasons' Hall, which was commissioned under the title The Masonic Peace Memorial Building. One of its main features is a bronze casket housing a roll of honour listing members who died in the 1914–18 conflict. The casket is typically elaborate. It rests on an ark lying in a reed bed, symbolizing a journey ended.

It is not clear if one overarching mind was responsible for the decoration of the interior, although much of the metalwork, including the roll of honour casket, is attributed to Walter Gilbert from H.H. Martyn & Co. of Cheltenham, which specialized in architectural woodwork, plasterwork and metal. Some of best work of this firm was for the staterooms of ocean liners, and it can also be found at the centre of Freemasons' Hall in the shape of the Grand Temple's massive bronze doors. These are set on balanced hinges and open at the merest pressure of a finger, although each weighs more than a ton. The design cast on the doors shows the building of the Temple of Solomon. Sword hilts lying flat on the surface are handles, the buried sword blades representing peace. The stylized, streamlined figures on the doors may have stepped off a mantelpiece from an apartment of the 1920s. In plain terms, Freemasons' Hall is an Art Deco building and the style and symbolism are well matched. The chequerboard black-and-white floor of the Grand

OPPOSITE *Marble-clad vestibule.*

OVERLEAF *Grand Temple with Grand Master's throne flanked by deputies' chairs. The chequered floor design carries significance.*

Temple, which seems a simple classic Modernist design, is in fact a symbol of diversity in Freemasonry.

The Grand Temple is used sixty times a year. Lined with marble, galleried and high ceilinged, its main features are three huge gilded thrones for the officials, the central one being for the Grand Master. In places there is an epic scale to the design with the ceiling comprising 1.5 million mosaic pieces set by Italian craftsmen.

On the first floor the processional corridor, 130 ft (40 m) long, is lined with Tasmanian blackwood, a form of mahogany said to be extinct, and is illuminated by a stained glass window with the figure of Justice shown blindfolded. Elsewhere are more than twenty lodge rooms, a library and a museum. The only strictly functional features visible are the internal courtyards glimpsed through the inner windows. These are made of white ceramic self-cleaning bricks. The courtyards do not seem to function as light wells as they do in County Hall, but Freemasons' Hall is not a gloomy place. It is a registered film and television location, and has masqueraded as MI5 headquarters in the television show *Spooks*.

A mosaic with an All-Seeing Eye at its centre, a frieze bearing signs of the zodiac, pentacles and compasses, ornamental blocks of stones both rough and finished: all the visual references in Freemasons' Hall seem profound. Yet despite the powerful symbolism, it seems that most visitors who take advantage of the tours, including *Da Vinci Code* enthusiasts, are quickly won over to the notion that Freemasonry is benign, and an effective charitable organization.

'That Dan Brown has got a lot to answer for,' says the guide ruefully to the visitors, 'but we have forgiven him.'

RIGHT *The mosaic ceiling of the Grand Temple. To the right is Helios the Sun God, the All-Seeing Eye, and a five-pointed star.*

OPPOSITE *The bronze doors to the Grand Temple, with panels telling the story of the building of King Solomon's temple: Old Testament imagery in an Art Deco style.*

BODY AND SOUL 215

QUEEN'S CLUB

The Queen's Club is a grassy green enclave almost hidden at the end of a residential street in red-bricked West Kensington. Dating from 1886, it claims to be the first multi-purpose sports complex to be built anywhere in the world. Today it is exclusively home to the racquet sports: tennis, squash and rackets, but over time it has hosted more than twenty major sports, including football, cricket and rugby. It tapped into the late-Victorian flowering of competitive sport and was once the home ground of Corinthian F.C., the princes of amateur football.

Lawn tennis is the sport most closely associated with the Queen's Club. The Lawn Tennis Association, the governing body of British tennis, owned the Queen's Club between 1953 and 2007. Looming fears that redevelopment of the site would greatly exceed its value as a sports club led to it being sold to its members. This protected the future of the Queen's Club Championships, the annual men's tournament held on grass since 1890, which is a precursor to Wimbledon and the unofficial warm-up for top players. The twelve grass courts at Queen's are rated as the best anywhere, possibly superior to those at Wimbledon itself.

Two rare sports played at Queens are rackets and real tennis, both games being played in substantial enclosed courts.

Rackets started in the eighteenth century, when it was played by the gentlemen inmates of two of London's debtors' prisons: King's Bench in Southwark and Fleet in Clerkenwell, and it exploited the prisons' most essential features: the walls.

Centre court and clubhouse, best known as venue for the Queen's Club Championship.

BODY AND SOUL 217

218 UNSEEN LONDON

The strangely skewed rules of such institutions permitted certain privileges, and there were four courts at King's Bench. Well-bred prisoners had spiced up the handball game fives by using tennis racquets. The game migrated to public schools, with Harrow being the first to gain a court. Queen's rackets courts date from 1880, by which time the code of the game had been established, based on a four-wall 30 × 60 ft (9 × 18 m) enclosed court, with a ceiling no less than 30 ft (9 m) high.

The wooden racquet is called a bat, and is used to hit a hard white ball that can travel at up to 180 mph. Some elements of the sport resemble squash, which began as an off-shoot of rackets, although the scoring system differs and the rules of the two sports have diverged substantially.

Queen's is also the national headquarters of real tennis, hosting the British Open every year. Real tennis is a precursor of lawn tennis, and its supporters claim that it has the oldest continuous annual world championship in sport, at over 250 years. A measure of the game's rarity is there are only forty-seven courts in the world, and two of those are at Queen's. The sport is known as *jeu de paume* in France (originally being played with the hand rather than with a racquet), 'court tennis' in the United States and 'royal tennis' in Australia.

Its heyday was in the sixteenth and seventeenth centuries, being played by members of the royalty in France and England. It became known as real tennis after the derived game of lawn tennis became the more widely known sport. Though similar in certain respects, with the same scoring system, two bounces of the ball does not bring necessarily bring the point to an end. Real tennis is claimed to be a more complex and technical sport, and the court is wider and longer than that for lawn tennis, enclosed by four walls – three of which have sloping roofs, known as penthouses – and a ceiling lofty enough to contain all but the highest lobs. There is also a buttress called a tambour, which intrudes into the playing area, and off which shots may be played. Points can be won by hitting the ball into certain spaces below the

Real tennis court from the dedans.

ABOVE *The real tennis racquet is asymmetrical, and the hand-made balls are heavy.*
OPPOSITE *A game of rackets in progress, photographed from the balcony.*

penthouses. The hand-made real tennis balls are heavier than those for lawn tennis, and ground strokes are favoured, which may be the reason that the wooden racquets for this sport are asymmetrical.

In 1908 Queen's Club hosted three events during the first London Olympics Games: rackets, covered court tennis (indoor tennis) and real tennis. This combination was not deemed successful for future Olympics.

For thirty years, the annual Oxford and Cambridge University rugby and football matches and athletics challenges took place at the Club, sometimes drawing as many as 10,000 spectators. As these events outgrew the Club's facilities, they found new homes at Twickenham, Wembley and White City. The increasingly popular game of lawn tennis took over the grounds of the Club, and there are twelve grass courts today.

BODY AND SOUL 221

LORD'S CRICKET GROUND

It is highly likely that Sir Nikolaus Pevsner, the celebrated historian of English architecture, was not especially interested in cricket; he described Lord's, long acknowledged as the game's spiritual home, as 'a jumble without aesthetic aspirations'. Were Pevsner alive today he would certainly revise that view, for in the late twentieth century the ground was redeveloped with a series of distinctive buildings that now circle the playing surface like a jewelled necklace.

In Pevsner's day the only building of note was the Pavilion, built in the High Victorian style so deeply distrusted by Modernists. Lord's itself dates from 1814, being the third cricket ground established by the eponymous Thomas Lord in the vicinity of St John's Wood as home to the Marylebone Cricket Club – then, as now, the guardians of the sport. By the late nineteenth century the MCC required a new pavilion and commissioned the architect Thomas Verity, who in 1871 had played a key role in the design of the Royal Albert Hall, where the distinctive terracotta facings clearly anticipate those at Lord's. The building opened in 1891, at a cost of £21,000, and was restored in 2005. In the words of a contemporary account, Verity provided 'a large saloon, offices, dressing and bath rooms, canteen, retiring room and accommodation for 2,000 on terrace, balcony and roofs'. But he also provided so much more, for this is the building that confirmed the MCC's position, in the words of one nineteenth-century commentator, as 'perhaps the most revered institution in the British Empire'.

The Lord's Pavilion is a cross between a country house and a luxurious gentleman's club. The building's central Long Room (or saloon, as it was described in 1891) brings together both members and the players, who must pass through it on their way to and from the pitch. The dressing rooms are located beyond the Long Room and up a grand staircase, and along this

The BBC Test Match Special *commentary box on the upper tier of the Media Centre, home of an institution within an institution.*

RIGHT *The away team showers.*
OPPOSITE ABOVE *The splendid gentlemen's lavatories in the pavilion basement.*
OPPOSITE BELOW *Most of the systems for maintaining the hallowed turf are conventional machines, as seen in the mower shed.*
OVERLEAF *The home team dressing room, overlooked by the honours board denoting Test Match century scorers and leading wicket takers.*

rather tortuous route the disappointed, or exultant, cricketer will come into contact with many rather more relaxed MCC members. There are around 18,000 men, and rather fewer women, entitled to wear MCC colours, and the twenty-year waiting list eventually gives access to other myriad facilities at Lord's, from the elegant dining and writing rooms in the Pavilion to one of the few real tennis courts in the country.

The past is always present at Lord's. The MCC maintains a museum, the centrepiece of which is the tiny Ashes urn, the prize contested by England and Australia since 1882. W.G. Grace, a titan of the nineteenth-century game, is commemorated by the Grace Gates outside the ground. A short distance from these gates is a striking relief sculpture from 1934, showing a procession of thirteen sportsmen and women, above whose heads is the Victorian admonition: 'Play Up, Play Up and Play the Game'.

In 1987 the MCC belied its hidebound reputation with the construction of the Mound Stand, a building so accomplished, light and graceful that it caused the *Architects' Journal* to speculate that 'post-war UK architecture may come to be labelled either pre- or post-Lord's, for the new stand can well be seen as the point at which the warring factions of modernism and conservation evaporated'. The architects, Michael Hopkins and Partners, roofed the stand with tent-like cones to produce a motif that has been replicated at sporting arenas around the world. The cones are supported by a slim steel structure that in turn rests on more powerful brick arches retained from the stand's predecessor. Where new arches had to be constructed the architects specified second-hand bricks, so it is impossible to distinguish new from old.

In 1999 the MCC came up with something still more remarkable. This was the new Media Centre, by the architects Future Systems, which stares over Lord's like the lens of a giant camera. The building was fabricated from aluminium in a Cornish boatyard and re-erected in St John's Wood. It won the Stirling Prize for contemporary architecture and the tiered desks, stretched across its vibrant blue interior, provide a sensational view of the action below. However, cricket journalists grumble that its principal designer, the Czech-born Jan Kaplický, understood little of their game, as only one tiny window in the building opens, thus sealing the interior from the sound and atmosphere of the drama outside.

Much has changed since Pevsner made his disparaging comments, but one small feature remains from the days of Thomas Lord himself. This is a slope across the playing surface, which drops fully 6 ft 8 in (1.8 m) from one corner to the other. There is no other major sporting venue in the world where such an anomaly survives.

BODY AND SOUL 225

REPTON BOXING CLUB

A fine Victorian bathhouse in Bethnal Green is home to the best-known amateur boxing establishment in Britain, Repton Boxing Club, with a history dating back to 1884 for the improvement of deprived boys of the East End. The area is now modernized and residentially desirable, but the club just off Brick Lane looks just as it might have done in the 1930s. There is a good patina on white glazed tile walls, distressed woodwork, yellowing bout bills, battered punchbags and a well-used square ring. All this creates an authentic atmosphere for a casual visitor, but it is a little deceptive. Repton Boxing Club has been based at the Cheshire Street bathhouse since only 1978, having been housed at multiple locations in the East End previously. Boxing and the building represent two separate slices of East End culture.

Repton Boys' Club, as it was originally named, was founded through the philanthropy of Repton School. The precise reason why a public school based 130 miles (210 km) north of London in Derbyshire should adopt the East End is now obscure, but it was likely based on a combination of idealism and practicality. To the privileged classes in late-Victorian England the East End of London was the very definition of neediness and deprivation. A boys' club with a sporting side was seen as a way of alleviating hardship.

Connections between the school and club died had died away by 1971, but the name – by then Repton Boxing Club – continued, and its roll of honour has been impressive. The amateur club launched world Welterweight champion John H. Stracey, WBC Jr. Middleweight champion Maurice Hope, Olympians Mickey Carter and Sylvester Mittee. World Middleweight champion Darren Barker started at Repton and Audley Harrison won the ABA championship as a Repton fighter.

The club is shrewdly aware of the strong character of the place, preserving its 'retro' look and allowing it to be used as a location in *Lock, Stock and Two Smoking Barrels* and other films. Club officials also emphasise that Repton is the real thing, not a leisure centre or a fitness centre, but strictly for those who aspire to three rounds of action, with shirts on, and headguards worn. For the ambitious it may be a pathway to a shot at greatness, and for some boys it is said to be a steadying influence and a source of self-respect, which was one of the principles behind the founding of the club in 1884.

The surrounding bricks and mortar of the Bethnal Green Baths and Washhouse are the testament of the Second Public Baths and Washhouses Act of 1897. It provided baths for personal washing and facilities for laundering. Architect Robert Stephen Ayling specialized in social works that required high levels of hygiene, such as abattoirs and public conveniences. His design won praise at the time for providing space for prams, 'in which the washers usually bring their linen. In most of the London baths this been omitted, with the result that the waiting halls are often impassable.'

It is built from red brick and bands of Portland stone, with a curved gable end owing something to Flemish style, and its

The military slogan 'No Guts No Glory' inspires fierce sporting endeavour.

NO GUTS NO GLORY

decorations include a relief of carved cherubs over the male and female entrances signed by scrolls held by cherubs, and at its eastern end is an oriel window buttressed by carved angels. Equipment once housed within the laundry included hand-powered mangles and some monumental belt-driven washing machines.

The need for public baths declined swiftly with facilities built into new housing after the Second World War, and the entire bathhouse building was falling into disuse by the 1970s. By coincidence, Repton Club's lease on space at the Bethnal Green Working Men's Club in nearby Pollard Row was coming to an end. With some financial aid from Tower Hamlets, the single-storey laundry washhouse part of the building was upgraded to accommodate the boxing club with no loss of sporting continuity.

As years passed, and as much of the building remained closed, the East End began to change. With the revitalized City of London lying close alongside and generating an increasing need for good accommodation, it was inevitable that the rest of the building would be transformed into desirable apartments.

ABOVE *The Wall of Honour against the green and cream scheme inherited from the former Bethnal Green Bath and Wash House.*

OPPOSITE ABOVE *Cherubs, indicating separate bathing arrangements, remain on the largely unchanged exterior.*

OPPOSITE BELOW *Repton Amateur Boxing Club, formerly Repton Boys' Club, has a timeline unmatched in sport.*

OVERLEAF *Wall-suspended punch bags alongside the ring, where mangles and washing machines once stood.*

BODY AND SOUL 231

THE SQUARE MILE

MIDLAND BANK

Midland Bank was once the largest deposit bank in the world, and its head office in Poultry, just a few steps from the Bank of England in the City, was a purposeful palace of finance in a prime location. It has been reborn as luxury hotel and member's club called The Ned, after the nickname of its architect, the venerated Edwin Lutyens.

Luytens was responsible for the imposing façade and many of the interior spaces. The most impressive of these is the enormous banking hall, laid out in the shape of a cross lined with classical columns of green African verdite, most of which are square in section. Contrasting white marble covers the walls, and teak provides the surfaces of the counters. The lofty aisles intersect over a light well that illuminates the lower floors. When it was first opened, some said the design resembled a booking hall in a railway terminus, but the sense of solidity and prosperity was palpable. When Lutyens was commissioned to design the bank in 1924, he had come a long way from drawing vernacular English cottages designed to nestle perfectly in the Surrey countryside. A link with those days was his collaborator Gertrude Jekyll, garden designer, who was related to the Midland chairman Reginald McKenna, and who seems to have forged a connection between them. In any case, Lutyens was by then famous and well into his grand period, and Midland Bank wanted prestige and branding.

John Gotch and Charles Saunders, the other architects

PREVIOUS PAGES *Midland Bank, safe deposit boxes.*
LEFT *The impressive intersection of the ground floor banking hall with columns of strikingly square section; the central desk was once a light well for the basement floors.*
OVERLEAF *Safe deposit entrance with 25-ton vault door, guarding 3,800 private boxes of varying sizes.*

OPPOSITE *This cabinet in the boardroom corridor, for the storage of directors' top hats and canes, has been attributed to the architect Edwin Lutyens himself.*
ABOVE *The oak-panelled fifth-floor boardroom, with a large tapestry made by Arthur Lee on the upper wall. All the significant Lutyens-designed offices on the fourth and fifth floors remain intact.*

engaged, designed over 140 branches for the Midland after the First World War. Between them, the result at the headquarters building was an unmistakably modern bank with a strong corporate identity. The upper-floor offices for the chairman and directors, the boardroom, staircases and even some of the furniture has been attributed to Lutyens.

One of influences on the exterior was the fact that Poultry is comparatively narrow, making it hard to obtain a good view of the bank from street level. Lutyens designed a small degree of setback, storey by storey, and reduced the depth of the Portland stone courses layer by layer upwards. The optical result is to increase the impression of height, of a tall building receding into the sky. For the safe deposit area on the lower ground floor he designed another grand space, and the Chatsworth Safe Company manufactured a state-of-the-art 25-ton circular strongroom door, finely balanced on precision hinges. It was installed after first being shown at Wembley's British Empire Exhibition in 1924 as a modern wonder. Built in stages between

ABOVE *The grandeur of the management's suite of offices on the fourth floor.*
OPPOSITE *Spiral staircase.*

1925 and 1939, the bank properly belongs to the twilight era of British global influence and power. Midland Bank had been founded in Birmingham in 1836, and had been shrewdly developed, gaining a place in the capital by acquisition of two London banks in the 1890s. After the Second World War, Midland took its place as one of the big four British clearing banks, and the head office was maintained and expanded. By 1992 the Hong Kong and Shanghai Banking Corporation (HSBC) had fully absorbed Midland, and banking came to end in the building when HSBC sold it off in 2005. Soho House and the US Sydell Group acquired the building in 2012 and announced plans for a boutique 250-room hotel and members' club in a luxurious but unstuffy style with spa, gym, and roof terraces.

The bank was photographed here in April 2014 in its original form just before the conversion started. Seven restaurants now occupy the banking hall between the preserved columns and counters. A members' club bar lies behind the strong room door, its walls still lined floor to ceiling with safe deposit boxes and the directors' rooms on the four and fifth floors have become event spaces.

BANK OF ENGLAND

The Bank of England building is an imperial neo-classical seven-storey structure of the early twentieth century looming over a long perimeter wall built a hundred years earlier. Taken together, these two elements once caused a great controversy. Many architectural studies dismiss the building, designed by Sir Herbert Baker in 1921, as dull, bombastic or unimaginative, and describe the wall as the greatest feature of the bank.

Eight architects have been associated with the building since its establishment in Threadneedle Street in 1734, but only Sir John Soane's work between 1788 to 1828 has been described as a masterpiece. Over forty years he created a series of offices, mostly no higher than three storeys, said to resemble a Roman basilica. Around this he designed a screening wall, devoid of windows, as it was designed as a fortified structure to resist attack. No lighting could come from the street side of the building, and many rooms are illuminated by a clever arrangement of top lighting. Only a single storey at the entrance portico projected above the wall. This building lasted for almost a century, and was being referred to as Soane's Bank or the Old Bank when the time to change it came after the First World War.

There was a compelling need to enlarge the bank as its responsibilities grew, and much of Soane's bank was demolished in four stages between 1925 and 1939 and replaced by the new building, seven storeys above ground and three below. Destruction of Soane's bank building generated great criticism at the time and since then the trend has been to increasingly venerate Soane's work and deride Baker's, although some sensitivity was shown both by the bank and the architect in

Entrance area on the first floor, with stone vaulted ceiling and wrought-iron balustrade carrying uplighters. The paintings are of former Governors and Directors, and the Committee of the Treasury.

the decision to preserve the wall and rebuild the bank. There had been calls by the City of London authorities for street widening, which would have required the demolition of at least one side of the Soane wall, and also pressure to modify the shape of the site, which is an awkward trapezium. Those proposals were resisted, the groundplan preserved and the result was a compromise of aesthetics, function and conservation, even if the building overpowers the wall.

Except for the eight gold bullion vaults spreading over two of the floors below ground, most of the functional working spaces of the Bank of England are unremarkable, but the formal rooms are stunning. Some rooms do survive from Soane's time, and from an earlier architect, Sir Robert Taylor, from 1765–70, although rooms and furnishings have been relocated in some cases, or recreated. The octagonal Committee Room, where interest rates are set by the Governor and the Monetary Policy Committee, retains its original ceiling design and marble chimney piece. The Court Room, in green, pink and gilt, represents Taylor's design and has fine plaster decoration and three marble chimneypieces. On a wall in this room is a replica wind direction indicator of 1805, driven by a shaft from a weathervane on the roof, which once helped inform the directors of the shipping arrivals. Soane's top-lit Bank Stock Office of 1792–3 was reconstructed by historic architecture specialists Higgins Gardner & Partners in 1986–8.

Today, an appreciation of Soane's wall at street level requires a walk of half a kilometre and some imagination. Made of channelled Portland stone, it lines Threadneedle Street, Prince's Street, Lothbury, and Bartholomew Lane, punctuated by fifty Corinthian columns and a number of pilaster low relief false columns, blind recesses and a single statue, which is of Soane himself. There are still no windows. A decorated frieze relieves the forbidding masonry on three sides. The colonnade which forms the north-west corner, or Tivoli Corner, was based on the Temple of Vesta, which the architect sketched during a visit to Italy in 1779. Along the length of the wall, Soane's classic symmetry and symbolically empty niches can be hard to appreciate from the narrow streets. All the original door openings remain now filled with modern bronze doors decorated by sculptor Sir Charles Wheeler.

OPPOSITE *The first-floor Committee Room, in an eighteenth-century style, where monthly meetings of the Monetary Policy Committee set the interest rate.*

ABOVE *Court Room, including a wind direction indicator above the middle arch on the end wall, driven by a weather vane on the roof. A strong wind from the east indicated that ships were approaching London and that the Bank should prepare money for increased levels of trading in the City.*

There is public access to the Bank of England Museum on the east side from Bartholomew Lane. The first room of the museum is a reconstruction of Soane's Bank Stock Office of 1793.

The Bank once contained a barracks housing a detachment of thirty soldiers, and a printing office where banknotes were produced. The Bank of England was founded in 1694 to raise money during a time of war and it spent the first forty years of its life in rented premises. It long functioned as a commercial bank as well as for raising money for the government and was still owned by private stockholders past the middle of the last century, but by then was acting effectively as a national central bank. It was nationalized in 1946, and became fully independent in 1998.

248 UNSEEN LONDON

OPPOSITE *A ring of swords and bayonets surround an image of Britannia. Previously, the Bank had its own barracks, and a detachment of soldiers protected the bank until 1973.*
LEFT *Bronze door on the Threadneedle Street entrance, with a caduceus design by Sir Charles Wheeler dating from 1930. The hand of Zeus grasps a bolt of lightning, symbolizing the electrical force powering modern banking.*
ABOVE *A mahogany secret ballot box designed by Sir John Soane, architect and surveyor to the Bank from 1788 to 1833, kept in the Court Room. Designed in the form of a miniature ancient Greek temple, with a palm tree roof design, it was used during the 1800s by the Bank's Court of Directors to cast votes at the end of countless important meetings. The ballot box enabled a voter to cast their ballot by reaching inside and dropping a small wooden ball to the left side for 'yes' or to the right for 'no'.*

MANSION HOUSE

Mansion House is the residence of the Lord Mayor of London and family during his or her year of office, and is also the Lord Mayor's place of work and official entertaining. It was completed in 1752, and has been described as one of the finest Georgian buildings in London. Situated close to the centre of the City of London, it is best known for hosting the Chancellor of the Exchequer's annual Mansion House Speech, reporting on the British economy. Its fine array of rooms were refurbished and restored in the 1990s.

The formal rooms include the Venetian Parlour, which is the Mayor's office, the Egyptian Hall Ballroom, Long Parlour and drawing rooms and state bedrooms. On the ground floor, the gold and silver vaults contain gifts presented to Lord Mayors and valuable pieces acquired by the Corporation. There was once a Justice Room, where the Lord Mayor, serving in the role of Chief Magistrate of the City, heard criminal cases. This is now called the Esquires' Office, and the cells in the basement are now wine cellars.

Originally, there had been no official residence, each Lord Mayor working from his own home or lodging in his livery company hall or Guildhall. The need to house the Mayor was raised after the Great Fire of London, reflecting a growing sense of power and prestige in London. Architect George Dance gave the building an impressive silhouette in the English Palladian style, which was becoming extremely fashionable in the early 1700s. The site chosen was a former produce market at the junction of several thoroughfares, opposite the new Bank of England.

The Venetian Parlour is the Lord Mayor's office; for a non-political and largely ceremonial appointment, the position still generates prodigious levels of paperwork, as seen in the desk trays.

252 UNSEEN LONDON

The Mansion House has never been immune to change, and has been remodelled in several places, losing and gaining floors, galleries, staircases and window openings over time. Two vast clerestory attics were both soon demolished, and one of its main original features, a central courtyard, lasted for less than fifty years before it was roofed over to create an enclosed saloon. This roof was replaced in 1862, but over the years rot, beetle infestation and fire damage took its toll and in the 1990s a stronger timber and steel roof with central glazing replaced it. If the Mansion House frontage today seems to be separated from the rushing traffic of Bank Place by only a meagre margin, that is because half of its approach steps and a whole front courtyard were swept away for road widening 180 years ago. Although it escaped a direct hit during the Blitz, Bank Underground station close by took a devastating hit and the resulting blast damage to Mansion House was repaired in 1948.

Despite extensive work carried out in 1931, it was clear by the end of the 1980s that a fresh start was needed for the Mansion House. Some of the original furniture had gone, decorations had deteriorated and certain carvings were found to have fifty layers of paint, which explained the softening of their outline. An extensive restoration carried out between 1991 and 1993 aimed to recreate the eighteenth-century Regency period, by assembling and sometimes remaking suites of period furniture and fabrics for the room settings. Surface finishes on doors, ceilings and walls were remade after research into the originals. Displayed throughout are paintings and sculpture, including pictures from the Samuel Collection of important Dutch paintings from the 1600s, bequeathed in 1987.

Out of sight, Mansion House includes a series of structural bracing tie-bars which were built into its walls and floors across all levels during the restoration. At the same time a massive steel frame was fitted behind the colonnade, also coupled to tie-bars. Mansion House had been found to be settling, with its east and west walls sagging, and the movement was increasing. The cause was the tangle of underground rail lines which had existed close below for more than a century, and which were about to be joined by the deep tunnels of the Docklands Light Railway. London Regional Transport authority was persuaded to change the planned direction of some of

OPPOSITE *The Lord Mayor's sword dates from the mid-seventeenth century, and the mace from 1735.*

LEFT *The north state bedroom, with a recreation of the domed bed of 1824. Dragons at the corners hold the arms of the City of London.*

the linking passageways, and the new pedestrian tunnel between the Waterloo & City line and the DLR was dug with minimal disturbance, largely by hand. The reinforcement and bracing measures adopted in Mansion House are almost impossible for a visitor to spot.

The Mansion House has its share of legends, one of the most persistent of which is that Emmeline Pankhurst, political activist and suffragette leader, was once imprisoned in a cell in the basement, although it is more likely that it was her daughter Sylvia, tried for publishing seditious material in 1920, who was briefly remanded here.

An intriguing object held in the vault is a 'collar of esses', reputedly once belonging to Sir Thomas More, bequeathed in 1535. It was worn for centuries as a ceremonial collar by successive Lord Mayors. Today a replica is worn.

The gold and silver vault on the ground floor house pieces given as gifts to Lord Mayors, including the original collar of esses, visible to the right, and the 'Fire Cup' of 1662, the only Corporation piece surviving intact dating from before the Great Fire.

THE SQUARE MILE 255

GUILDHALL

Guildhall, which is the Town Hall of the City of London, was completed in about 1440. Earlier buildings existed on the site serving the similar purposes since about 1128 or earlier, although no historian or archaeologist has ever pinned down exactly when London's first Guildhall was built.

It is arguable that Guildhall is the oldest surviving secular building in the City, and it can also be claimed that it possesses the greatest historical interest after the Tower of London. Guildhall is laden with layers of history and legend, a medieval building with Saxon and possibly Roman antecedents.

Oldest of the legends is that Brutus of Troy, who was the mythical first king of ancient Albion, had his palace on the site of Guildhall, with giants Gog and Magog chained to the gates. Fearsome effigies of Gog and Magog have consequently watched over the building's Great Hall for centuries. More feasible is that Dick Whittington financed the building of Guildhall. Richard Whittington (1354–1423) certainly served several terms as Lord Mayor, and was known as a wealthy trader who loaned money and left charitable bequests to benefit London.

Firmly rooted in history are ten notable state trials that were held in Guildhall in the turbulent years between 1546 and 1615, which are listed on a memorial tablet. Most famous were those of Lady Jane Grey, briefly Queen of England, and of Archbishop Thomas Cranmer, both tried for High Treason. Guildhall survived the Great Fire of London in 1666, although it was damaged and its roof burned off.

The Great Hall is an impressively high vaulted space attributed to a master mason named John Croxton. Its scale and proportion are impressive today, and must have been overwhelming to those who saw it in the 1440s. Each successive century bought extensive changes. George Dance the Younger added a porch in 1789, and the Victorians inevitably made an extensive external renovation, which changed many details and added a minstrel's gallery inside and a display of standards of measurements. The moment of greatest danger came on the night of 29–30 December 1940, when a heavy air raid started a series of fires across the City which began to join up, forming a fire storm that nearly overwhelmed parts of London as fire fighters struggled to keep the flames away.

Guildhall was saved, but again suffered severe damage. The roof and windows were mostly destroyed but the four walls still stood, and much of statuary inside remained intact, although the figures of Gog and Magog were again destroyed. These were replaced in 1954 and the next year the restoration was complete, with a new roof on steel cantilevers designed by Sir Giles Gilbert Scott, the fifth to be applied to date. A statue of Churchill was unveiled, joining those of Nelson and Wellington, Apollo, Mercury, Neptune and Britannia.

High on the walls are displayed pennants of the twelve leading livery companies of the City of London. Other rooms to the side of the Great Hall include the print room, the chief commoner's parlour and the old library.

The chief commoner's parlour room, with vaulted ceiling in Elizabethan style.

With the rebuilding of Guildhall, work was also completed to the west side on new offices for the Corporation of London and on the eastern side was built the Guildhall Art Gallery, designed by Richard Gilbert Scott in 1999. During work on the foundations, remains of a Roman amphitheatre were found 20 ft (6 m) below ground level in the yard of Guildhall. The amphitheatre was partially excavated and can now be accessed from Guildhall Art Gallery. On the surface of yard the internal dimensions of the amphitheatre have been outlined by a large circle. The discovery of the amphitheatre was a surprise to historians of Guildhall, who have revised assessments of the early buildings on site, estimating that the siting of an earlier Saxon Guildhall was influenced by the amphitheatre's position. Remains have also been found of a thirteenth-century gatehouse built directly over the southern entrance to the Roman amphitheatre. The current hall's west crypt may be part of another thirteenth-century building.

Today Guildhall – never expressed as 'The Guildhall' – is used for official functions, entertaining visiting heads of state and for the official installation of the Lord Mayor, and is the scene of an annual keynote speech by the Prime Minister.

ABOVE *Giants Magog (left) and Gog (right) oversee the Great Hall.*
OPPOSITE ABOVE *Guildhall Standards of Length.*
OPPOSITE BELOW *Stuart coat of arms removed from the church of St Michael Bassishaw just before it was demolished in 1897, during an archaeological excavation when the remains of the church's medieval foundations were uncovered. This plaster coat of arms, the grandest of those in any Wren church, is preserved in Guildhall.*
OVERLEAF *The Great Hall.*

THE SQUARE MILE 259

CITY OF LONDON SCHOOL

A walk along the full length of the Victoria Embankment from Westminster Bridge to Blackfriars Bridge passes many fine buildings, the last of which is an impressive Portland stone mansion with a steeply pitched roof carrying the title 'City of London School' over its doorway.

This building was the home of the City of London School for over a hundred years. The school once extended to the side and behind along John Carpenter Street to Tudor Street. Now the main block remains as part of the offices of JPMorgan's Treasury and Securities Services, which has developed a modern complex where the rest of the school buildings once stood.

The Victoria Embankment building was designed by architects Barrow Emanuel and Henry David Davis and constructed by John Mowlem. Architectural guides have variously described its style as 'Italian Renaissance', 'French neo-Renaissance' or 'High Victorian'. It does not particularly resemble a school. Sir Nikolaus Pevsner described the façade as 'amazingly unscholastic, rather like a permanent Exhibition Palace'. There is a hipped, green-slated roof which evokes a French chateau. The roof also carries dormers and a tall central lantern. To the sides are pavilions and cupolas. On the front of the building are statues of Shakespeare, Milton, Bacon and Newton, and allegorical figures illustrating scholarly subjects such as geometry and ancient history, which Pevsner seems to have missed. Columns of the Ionic and Corinthian order support arches around five deep windows facing the river.

Behind the windows lies its most notable interior feature, the Great Hall, which occupies almost the entire upper part

In the Great Hall transverse and longitudinal roof arches are supported on beams and columns and illuminated by dormers.

ABOVE *The façade of City of London School. Art historian Sir Nikolaus Pevsner described it as 'amazingly unscholastic, rather like a permanent exhibition palace'.*
OPPOSITE *The Imperial Staircase lined with marble ascends from the colonnaded lobby, in which three types of coloured marble are visible. The niche at the top of the stairs formerly carried a statue of the founder of City of London School, John Carpenter. This has been removed to the school's new premises to the east of Blackfriar's Bridge.*

of the building, and has a magnificent ceiling, supported by twenty arches above transverse tie beams and columns. A vaulted space is suggested, but much of the ceiling itself is flat. Viewed from floor level the whole of the inside open roof structure appears to be made of wood. Stained glass windows in the western and eastern sides of the hall are by the Covent Garden company Heaton, Butler and Bayne, prolific makers of stained glass during the Gothic Revival period.

The school needed more space and moved here from its previous home in Milk Street, reopening in 1883, having been embedded in the City of London for centuries. It was first endowed by John Carpenter, Town Clerk of London, in the year 1442. As a day school in the nineteenth century, it gained a reputation for enlightened attitudes to religion, open to Non-conformist and Jewish pupils. While other leading places of learning, such as Charterhouse, moved out of London to the country at the end of the century, the school stayed within the City. Former pupil Prime Minister Herbert Asquith said that the sound of Bow Bells and the roar of traffic in Cheapside was part of the 'stimulating environment' of the place, which was not an exaggeration. Even as late as 1879, when the school building was being planned, the area was still occupied in places with wharves, breweries, warehouses and factories.

To clear a site for the school, the City of London Gasworks was demolished, and the building stands where the old retort house and gasometers once did. The City of London authorities seem to have been keen to discourage the malodorous gas company from continuing at that site or in the City. The availability of land gained by the construction of the Victoria Embankment by Bazalgette between 1864 and 1870 is generally cited as the reason for the school being built here, although little land was reclaimed inside the roadway at the eastern end of the embankment.

BILLINGSGATE ROMAN HOUSE AND BATH

One of the most spectacular set of Roman remains in London – a house and bath at Billingsgate – is rarely open to visitors. It is necessary to check the Open House weekends scheduled in London during September to see if public access has been granted to the sub-basement of a certain office building in Lower Thames Street.

Victorian workmen found the remains while digging the foundations for the New Coal Exchange in January 1848 across the road from where the first Billingsgate market building was about to be constructed. Below the ruined old Dog Tavern, at a depth of 12 ft (3.5 m), they uncovered the ground plan of a Roman house, with walls remaining up to 3 ft (90 cm) high in places. At the centre was a small chamber mounted on pillars: a hypocaust, which was an ancient heating system. The remains were protected and arched over when the Coal Exchange was completed.

From the start the ruins benefited from a newly enlightened attitude by the City of London authorities. They were immediately recognized as a valuable find, and ranked as a major news story, generating a full page of coverage in the *Illustrated London News*. The first attempt to further excavate the area came as early as 1859. Under the Monuments Act of 1882, the Roman house and bath became one of the first scheduled monuments in London. They remained housed in the basement of the Coal Exchange until that building was demolished in 1963.

There have been further phases of excavation, and it has taken more than a century to develop a fuller picture of what the site represents. Archaeologists have calculated that it is a riverside house built in the second century, with a bathhouse added in its central yard during the following century. The house seems to have comprised two wings. It is not clear whether it was an expansive private villa or some kind of lodging establishment. Analysis continues, but the house would not have survived long after the end of Roman occupation, which came in AD 409–410. In the east part of the house a hoard of copper coins was found that included the image of Emperor Honorius, indicating a date later than 395 for continued Roman habitation. A Saxon brooch found in debris was disposed in a way that suggests that the tiled roofs of both buildings had collapsed by the middle of the fifth century.

Further excavations were made in 1967–70 when Lower Thames Street was being widened to become a dual carriageway. It became a main thoroughfare, a forbiddingly busy road. A new office building was being built and the Roman site ended up being hidden, but preserved, in a sub-basement under 100 Lower Thames Street. The concrete foundation piers of the modern building reach down into the ground alongside the delicate stacks of Roman tiles supporting the floor of the bathhouse. In the 1970s some cement capping was applied to the remains, which was found to be suffering from decay; later this work was removed and improved conservation methods applied.

Archaeologists and historians support the idea of full public access to the Billingsgate Roman House and Bath, but say this may only be feasible if major changes occur with the office building above.

Third-century bathhouse with pilae stacks, which are tiles built up into pillars supporting the floor as part of heating system.

PHOTOGRAPHER'S NOTE

A born and bred Londoner, for many years I lived in an apartment overlooking the River Thames between Chelsea and Vauxhall bridges, very close to Battersea Power Station. I have witnessed this architectural icon in a sad state of decline in the hands of a succession of property developers.

Despite being used as a location for many films and television programmes, this famous Grade II* listed building, with its wonderful iconic Art Deco interiors, was ripped apart, one wall and the roof removed and then neglected.

In 2010, after very long negotiations, my assistants and I were given access. Having donned hard hats, protective boots and fluorescent jackets, we spent a day photographing the interior. During the shoot, I realized that we were not alone, but that the site had become a sanctuary for all sorts of wildlife – thousands of pigeons, families of foxes, rats and peregrine falcons have all set up home there.

It seemed a shame that such a magnificent building had ended up in its present state, and the series of pictures gives at least a taste of its former splendour. Many photographs in this book will be the last record of a disappearing world.

I found taking these shots a stimulating experience. The pictures were well received by magazines and the Internet, and they became the starting point for a long journey of discovery, inspiring me on my mission to record hidden London, as it stands in the twenty-first century, for future generations.

The majority of the work was photographed on a Hasselblad 503CW camera, with a Leaf Aptus-II 10, 56 megapixels, digital back. I also used a Nikon D800 camera shooting on 14–24mm f2.8 lens for ultra-wide shots. Both cameras were tethered to a MacBook Pro laptop.

The locations for *Unseen London* were photographed over a period of four years, with access achieved through the generous help of friends and contacts made throughout my career, who were inspired by the concept. For me as a photographer it is a joy to be able to share photographs of my wonderful city.

Dazeley photographing Battersea Power Station, Generator Room B side.

PHOTOGRAPHER'S NOTE 269

INDEX

10 Downing Street 1, 76–81
 Cabinet Room 78–9, 81
 Pillared State Drawing Room 78
 State Dining Room 80
 Terracotta State Drawing Room 78, 81
 White State Drawing Room 77, 80

Abbey Mills Pumping Station 31–3
Abbey Road Studios 142–5
Adam, Robert 120, 122
Albert Memorial 87
Aldwych Underground station 42–5
Alexander, Field Marshall Harold 70
Alexandra Palace 146
All Souls Church, Portland Place 152
Allen, Godfrey 198
Angel, Daniel 156–8
Angels Costumes 156–9
Anrep, Boris 203
Armstead, Henry Hugh 55
Armstrong, William 22
Ashley, Henry 211
Asquith, Herbert 138, 264
Atkinson, Robert 160, 164, 165
Audsley, George 192
Aumonier, Eric 160, 165
Ayling, Robert Stephen 228
Ayrton, Thomas 61

Bacon, Francis 263
Baker, Herbert 245
Baldwin of Forde (Archbishop of Canterbury) 195
Baldwin, Stanley 70
Bank of England 244–9
Bankside 9, 17, 22
Banqueting House 116, 182–5
Barker, Darren 228
Barking 31, 32
Barry, Charles 61
Barry, Edward Middleton 208
Barry, John Wolfe 20
Bassey, Shirley 142
Battersea Power Station 12–19, 268–9
Bayswater 191, 203
Bazalgette, Joseph 31, 47, 264
BBC 36, 146, 149–50, 152, 155, 222
Beatles, The 142–5
Beaverbrook, Lord 160
Beckton Gas Works 32
Bentham, Jeremy 98
Best, George 90
Bethnal Green 228
Big Ben 60–5, 66
Biggs, Ronnie 101
Billingsgate Roman House and Bath 6, 266–7
Birmingham 36, 66, 100, 242
Blackfriars 47
Blackfriars Bridge 263
Blake, Sir Peter 85
Blitz 66, 95, 155, 196, 197, 198, 203, 253
Blyth, James 186

Boleyn, Anne 172, 175
Bow Street Magistrates' Court 88–91
Bow Street Runners 90
Broadcasting House 36, 152–5
 BBC Radio Theatre 155
Bromley-by-Bow 32
Brown, Dan 214
Brutus of Troy 257
BT Tower 36–41
Bunhill Fields Burial Grounds 105
Burges, William 72
Byron, Lord 70, 72

Cabinet War Rooms 124
Cambridge, 1st Duke 131
Campbell-Bannerman, Henry 81
Canaletto 110, 112
Cardigan, 7th Earl 70
Carpenter, John 263, 264
Carter, Mickey 228
Casals, Pablo 142
Casement, Sir Roger 89
Catherine, Queen 121
Caxton, William 198
Charles I 116, 121, 182, 185, 196, 197
Charles II 112, 118, 121, 122
Chelsea pensioner 121
Chermayeff, Serge 155
Chippendale, Thomas 78
Churchill Gardens Estate 17
Churchill, Winston 22, 70, 76, 78, 81, 124, 138, 257
City of London 95, 105, 107, 198, 230, 234–67
City of London Police 105
City of London School 9, 262–5
Cleere, William 122
Clerkenwell 216
Clive, Robert 55
Coates, Wells 155
County Hall 9, 50–3, 214
Couse, Kenton 78
Covent Garden 156, 211, 264
Cranmer, Thomas (Archbishop of Canterbury) 196, 257
cricket 105, 216, 222–7
Crippen, Hawley Harvey 89, 91, 95
Cromwell, Oliver 77, 171–2
Cromwell, Thomas 197
Crossness Pumping Station 30–5
Croxton, John 257
Crystal Palace 55
Cumberbatch, Benedict 70

Daily Express Building 9, 160–5
 Aitken House 165
Dance, George 250, 257
Dare, Virginia 201
Dartford 22
Davenport, Edward 186
Davis, Henry David 263
Dawbarn, Graham 149
de Rothschild, Baron Lionel 191
de Worde, Wynkyn 198

Denison, Edmund Beckett (Lord Grimthorpe) 61
Dent, E.J. 61
Diana, Princess of Wales 208
Dickens, Charles 93, 95
Disraeli, Benjamin 80
Docklands Light Railway 253–4
Dollis Hill 124
Downing Street 55, 76–81, 124
Downing, George 77
Draper, Charles 24
Driver, Charles 31
Dryden, John 201

Edward V 175
Edward VI 171
Edward VII 57
Egremont, Charles 2nd Earl 132
Elephant & Castle Underground station 45
Elgar, Edgar 142
Elgin Marbles 45
Elizabeth I 70, 72, 78, 112, 175
Elizabeth II 72, 66
Emanuel, Barrow 263
EMI 142–5
Emmett, William 122
English Heritage 144, 145, 149, 192
Environment Agency 28
Erasmus 196
Erith 32

Fawkes, Guy 175, 176
Fielding, Henry 90
Fields, Gracie 142
film and television 45, 146–55, 159, 186, 214, 228, 268
Finsbury Park Underground station 44
First World War 57, 72, 138, 211, 241, 245
fives 72, 219
Fleet Prison 216
Fleet, River 47
Fleming, Ian 131
Flowers, Tommy 126
football 31, 90, 186, 216, 220
Foreign and Commonwealth Office 54–9
 Durbar Court 55, 57, 58–9
 Grand Staircase 54
 India Office Council Chamber 55
 Locarno Suite 56–7
Fox, Charles James 55
Fox, Edward 70
Fox, James 70
Fox, Stephen 121
Franklin, Benjamin 201
Freemasons' Hall 210–15
 Grand Temple 211–15

Gaiety Theatre 43
George II 77, 168
George V 181
Geroge VI 186
Gibbons, Grinling 121, 171

Gilbert, Walter 211
Gill, Eric 155
Gladstone, William 80
Gloucester Road Underground station 45
Gog and Magog 257, 258
Goldman Sachs 165, 201
Grace, W.G. 224
Great Fire of London 66, 198, 250, 254, 257
Great Ormond Street Hospital, see St Christopher's Chapel
Great Plague 198
Great Stink of 1858 31
Greater London Council 50, 52, 53, 126
Green Park 131
Greenwich University 110
Grey, Lady Jane 85, 175, 257
Grove, John 122
Guildhall 105, 256–61
Guildhall Art Gallery 258
Gunpowder Plot 175, 178–9
Gwyn, Nell 118

Hall, Benjamin 61
Hammersmith Underground station 44
Hampstead 47
Hampton Court Palace 168–73
 astronomical clock 170, 171, 172
 Chapel Royal 168–9, 171
Harrison, Audley 228
Harrow School 70–5, 219
 Alex Fitch Room 70–1, 72
 Fourth Form 70, 72
 rackets court 72
 Speech Room 72, 74–5
Hastings, Warren 55
Hawksmoor, Nicholas 112
Hay's Wharf 22
Heath, Edward 80
Henry III 85, 176
Henry VI 112
Henry VIII 112, 168, 171, 172, 176, 181, 196, 197
Henry VIII's Wine Cellar 180–1
Henry Frederick, Prince of Wales 197
Hill, Daniel 100
Historic England 14
Holbein the Younger, Hans 196
Holborn 211
 Underground station 45, 45
Holloway Road Underground station 45
Honourable Artillery Company (HAC) 104–9
 Armoury House 105, 107
 Finsbury Barracks 107
 Long Room 107, 108–9
Honorius, Roman Emperor 267
Hope, Maurice 228
Horse Guards 114–17
Household Cavalry Mounted Regiment (HCMR) 115–17
Howard, Jane 175
Hughes, Alan and Kathryn 66

INDEX

Hurley Robertson & Associates 165
Huxley-Jones, Thomas Bayliss 146
Hyde Park Barracks 115–17
hydraulic power 22, 28, 186, 208

Illustrated London News 267
In and Out Club 6, 130–5

James I 178, 182–5
James II 122
Jekyll, Gertrude 237
John, King 85
Jones, Inigo 110, 182
Joyce, William (Lord Haw-Haw) 89, 101
Juxon, William (Archbishop of Canterbury) 196–7

Kaplický, Jan 224
Kent, William 77
Kidderpore Reservoire 6, 46–7
King, Martin Luther 85, 90
King's Bench Prison 216
Kingsway 44
Kitchener, Herbert 138
Knott, Ralph 32
Kray, Ronald and Reginald 90, 91, 95

Lambeth Palace 194–7
 Lollard's Tower 196
Larry 81
Laud, William (Archbishop of Canterbury) 196
Lawn Tennis Association 216
Lawrence, Thomas Edward 131, 138
Lebrun, Albert François 57
Lee, Arthur 241
Liberty Bell, Philadelphia 66
Liverpool 66, 192
livery companies 105, 250, 257
Lloyd George, David 138
Logue, Lionel 186
London Aquarium 53
London Bridge 20
London Dungeon 53
London Electric Railway 45
London Eye 50, 53
London Hydraulic Power Company 22, 186
London Marriott Hotel 53
London Passenger Transport Board 45
London Regional Transport 253
London Symphony Orchestra 142
Lord Mayor of London 105, 250, 253, 254, 257, 258
Lord, Thomas 222, 224
Lord's Cricket Ground 222–7
 Long Room 222
 Media Centre 222, 224
Lutyens, Edwin 237, 241
Lyon, John 70, 72

Magna Carta 85
Macmillan, Harold 80
Macmillan, Iain 144
Malmesbury, Lord 55
Mansion House 105, 250–5
Martin, George 142
Mary II 168, 185
Marylebone Cricket Club 222–7
McGrath, Raymond 155

McKenna, Reginald 237
McMorran & Whitby Architects 97
Menuhin, Yehudi 142
Menzies, Robert 124
Metcalfe, Julian 70
Metropolitan Board of Works 31
Middlesex Crown Court 82
Midland Bank 236–43
Miller, Glenn 142
Milton, John 201
Ministry of Defence (War Office) 136–9, 181
Ministry of Transport 181
Mittee, Sylvester 228
Mitterand, François 78
Montagu, Samuel 191–2
More, Thomas 87, 176, 177, 195, 197, 254
Morton, John (cardinal) 197
Mountford, Edward, William 93
Mowlem, John 263
Museum Telephone Exchange 36
Myer, George Val 152

Napoleonic Wars 77, 122
Naval and Military Club, *see* In and Out Club
Nehru, Jawaharlal 70
Nelson, Horatio 257
New Coal Exchange 267
New Fresh Wharf 22
New West End Synagogue 190–3
Newgate Prison 93, 95, 97, 98
Newman, Francis Winton 211
Nine Elms 13

Old Bailey 92–7
 Court No. 1 92–3, 96
 Great Hall 94, 95
Old Royal Naval College 9, 110–13
 Chapel 112
 King William Building 112
 Painted Hall 112
 Queen Mary Building 110–11, 112
Old War Office 5, 136–9
Olympic Games 220
Open House London 9, 267

Paddington station 57
'Paddock' 6, 124–9
Palace of Westminster 61, 87, 116. 137
Palladio, Andrea 182
Palmerston, Lord 55, 70, 131
Pankhurst, Emmeline 89, 254
Parliament Square 82
Paul VI, Pope 195
Pepys, Samuel 231
Pevsner, Nikolaus 85, 222, 224, 263, 264
Philip, John Birnie 55
Piccadilly 131, 132
Pimlico 13, 17
Pinochet, Augusto 90
Piper, John 149
Provisional IRA 78, 95, 117

Queen Elizabeth II Bridge 22
Queen's Club 216–21
Queen's House, Greenwich 110, 112
Queensberry, John Douglas, 9th Marquess of 89

Ram Brewery 6–7, 8–9
Ramsey, Michael (Archbishop of Canterbury) 195
Ray, James Earl 90
real tennis 216–19
Rendel Palmer & Tritton 24
Repton Boxing Club 228–33
Reuben, David and Simon 131
Reuters 201
Richard, Cliff 142
Robeson, Paul 142
Romans 6, 97, 198, 201, 257, 258, 266–7
Rotherhithe 22
Royal Albert Hall 222
Royal Courts of Justice 85–7
Royal Hospital Chelsea 118–23
 Chapel 118–19
 Council Chamber 120, 122
 Great Hall 121
Royal Opera House 91
Rubens, Peter Paul 182–5
rugby 105, 216, 220
Runcie, Robert (Archbishop of Canterbury) 195
Russell, Bertrand 90
Rysbrack, Jan Michael 55

St Bride's Church, Fleet Street 198–201
St Christopher's Chapel 4–5, 208–9
St Clement Danes 44
St James Garlickhyth 66
St James's Park 77, 131, 137, 185
St John's Wood 144, 222, 224
St Mary-le-Bow 66
St Pancras station 87
St Sophia's Greek Orthodox Cathedral 202–7
Salisbury, 3rd Marquess 57
Saunders, Charles 237
Scott, George Gilbert 55, 203
Scott, Giles Gilbert 17, 203, 257
Scott, John Oldrid 203
Scott, Richard Gilbert 258
Second World War 53, 66, 95, 124, 138, 144, 146, 155, 185, 192, 195, 196, 197, 203, 230, 242
 see also Blitz
Seymour, Jane 171
Shaftesbury Avenue 158
Shakespeare, William 150, 263
Shepherd's Bush 146
Soane, John 80, 122, 245–7, 249
Southwark 216
squash 72, 216, 219
Stracey, John H. 228
Strand 43, 87
 Underground station, *see* Aldwych
Sullivan, David 186
Summerson, John 112
Supreme Court 82–5
 Law Library 85
Sutcliffe, Peter 95

Tate Modern 17
Taylor, Sir John 91
Taylor, Robert 246
television 6, 36, 45, 146–51, 152–5, 158, 214
Television Centre, White City 6, 166–71

Thames, River 12–17, 18–23, 25, 51, 108, 124, 125, 206, 224, 289, 301
Thames Barrier 6, 24–9
Thames Water 31, 47
Thamesmead 33
Thatcher, Margaret 77, 78–80, 81
Thornhill, James 110
Top of the Tower Restaurant 36
Tower Bridge 6, 20–3
Tower of London 174–9
 Byward Tower 175, 176, 177
Trollope, Anthony 70
Tufnell Park Underground station 45
Turner, J.M.W. 77
Twickenham 220

Underground 17, 42–5, 155, 253

Van Dyke, Anthony 121, 197
Vauxhall Bridge 268
Verity, Thomas 222
Victoria, Queen 33, 72, 87, 121, 168
Victoria Embankment 263, 264
Villiers Street 50

Waad, Sir William 175
Walpole, Robert 77, 78
Wandle, River 9
Wandsworth Prison 98–101
Wapping 22
War Office, *see* Old War Office
Waterloo Underground station 43, 45, 254
Wellington, Duke of 121, 257
Wembley 220, 241
West Ham United football club 186
West Kensington 216
West Middlesex Water Company 47
Westlake, Nathaniel 192
Westminster Abbey 85
Westminster Bridge 53, 263
Westminster Cathedral 203
Wheeler, Charles 246, 249
White City 146–51, 220
Whitechapel Bell Foundry 66–9
Whitehall 55, 115, 116, 124, 137, 138–9, 181, 185
Whitehall Palae 181, 182
Whittington, Richard (Dick) 257
Wilde, Oscar 89, 91
William III 168, 185
Williams, Owen 160, 164
Wilson, Harold 81
Winslow, Edward 20
Wolsey, Thomas 168, 171, 181
Woolwich 24, 32, 33
Wren, Christopher 77, 110, 112, 118, 120, 121, 122, 168, 171, 198, 258
Wyatt, Matthew Digby 55

Yerkes, Charles Tyson 44

Unseen London is dedicated to my parents William and Freda Dazeley MBE and to my family Jannith, Tiger and Indigo.

ACKNOWLEDGEMENTS

I would like to thank my family, Jannith, Tiger and Indigo, for all their encouragement; Mark Daly for his fantastic contribution and insight; my digital assistants Alyssa Boni and Florian Hess; digital manager Esther Salmon; agent and producer Sarah Ryder Richardson; my publisher Andrew Dunn at Frances Lincoln Ltd for believing in the project; editor Michael Brunström and designer Sarah Allberrey at Frances Lincoln for their invaluable expertise; Brian Stater for sharing his sporting expertise and his great knowledge of London; Marie Cameron and Paul Murray for their assistance in research. Finally, enormous thanks for the kindness and generosity of all the locations that allowed me access and helped make *Unseen London* happen.

Brimming with creative inspiration, how-to projects and useful information to enrich your everyday life, Quarto Knows is a favourite destination for those pursing their interests and passions. Visit our site and dig deeper with our books into your area of interest: Quarto Creates, Quarto Cooks, Quarto Homes, Quarto Lives, Quarto Drives, Quarto Explores, Quarto Gifts, or Quarto Kids.

Unseen London
Copyright © 2014, 2017 Quarto Publishing plc
Text copyright © 2014, 2017 Mark Daly
Photographs copyright © 2014, 2017 Peter Dazeley
First published in 2014 by Frances Lincoln Ltd,
an imprint of The Quarto Group
The Old Brewery, 6 Blundell Street,
London N7 9BH, United Kingdom
T (0) 20 7700 6700 F (0)20 7700 8066
www.QuartoKnows.com

Revised edition 2017

All rights reserved.
No part of this publication may be reproduced, stored in a retrieval system, or transmitted, in any form, or by any means, electronic, mechanical, photocopying, recording or otherwise without the prior written permission of the publisher or a licence permitting restricted copying. In the United Kingdom such licences are issued by the Copyright Licensing Agency, Barnards Inn, 86 Fetter Lane, London EC4A 1EN.

A catalogue record for this book is available from the British Library.

978-0-7112-3907-4

Printed and bound in China
9 8 7 6 5 4